Will Gorlitz nowhere if not here

Will Gorlitz
nowhere if not here

BRUCE W. FERGUSON

PEGGY GALE

JEFFREY SPALDING

DAVID URBAN

Wilfrid Laurier University Press

[WLU]

We acknowledge the support of the Canada Council for the Arts for our publishing program. We acknowledge the financial support of the Government of Canada through the Book Publishing Industry Development Program for our publishing activities.

 Canada Council Conseil des Arts
for the Arts du Canada

 ONTARIO ARTS COUNCIL
CONSEIL DES ARTS DE L'ONTARIO

Library and Archives Canada Cataloguing in Publication

Gorlitz, Will, 1952–
Will Gorlitz : nowhere if not here / essays by Bruce W. Ferguson ...
[et al.].

Co-published by: Kitchener-Waterloo Art Gallery.
Includes bibliographical references.
Catalogue to accompany the travelling exhibition *nowhere if not here,* opening at the KW/AG Sept. 19, 2008–Jan. 4, 2009.
ISBN 978-1-55458-049-1

1. Gorlitz, Will, 1952– —Exhibitions. I. Ferguson, Bruce W.
II. Kitchener-Waterloo Art Gallery III. Macdonald Stewart Art Centre IV. Title.
V. Title: Will Gorlitz: nowhere if not here.

ND249.G6825A4 2009 759.11 C2008-907734-2

Cover and interior design by Kathe Gray Design.
Photographs by Toni Hafkenscheid (pp. 11, 16, 19, 27, 28, 30–33, 38–48, 49–54, 56, 58, 67, 78, 83, 85) and Cheryl O'Brien (pp. 29, 34–37, 55, 57, 59, 60–62, 65, 76).

 KITCHENER - WATERLOO
ART GALLERY

Co-published with the Kitchener-Waterloo Art Gallery

© 2009 Wilfrid Laurier University Press
Waterloo, Ontario, Canada
www.wlupress.wlu.ca

This book is printed on Ancient Forest Friendly paper (100% post-consumer recycled).

Printed in Canada

FRONT COVER *Numerals,* 2008 (oil on canvas, detail)
BACK COVER *Peripherum View I,* 1996 (oil on canvas, detail)

Contents

Foreword

*N*OWHERE IF NOT HERE, A NATIONALLY TOURING SURVEY exhibition of nearly twenty years of Will Gorlitz's work, is evidence of the Kitchener-Waterloo Art Gallery's ongoing commitment to showcasing regional artists whose work in its quality and quantity demands our institution's attention. Consequentially, our intention to expose important work to an interested audience through exhibition, publication, and national touring led to a wonderful partnership opportunity with the Macdonald Stewart Art Centre, whose extensive publishing history facilitated the production of this book.

A glance at our history reveals that KW|AG organized Tony Urquhart's nationally touring *25 Year Retrospective* (1978) as well as hosted *The Power of Invention: Drawings from Seven Decades* (2002), curated by Terrence Heath through the auspices of Museum London. In partnership with the University of Waterloo Art Gallery, KW|AG undertook the organization of Art Green's *Heavy Weather* exhibition (2005), which examined forty years of the artist's production and was accompanied by a comprehensive catalogue featuring the writing of Gary Michael Dault. Each of these artists is a teacher and mentor, and each possesses an artistic reputation that extends beyond the borders of our region and was gained through exhibition, publication, and critical review. KW|AG remains committed to exhibitions of this nature and continues to plan for future surveys.

I would like to express special thanks to Will Gorlitz for accepting our invitation, for the thoughtful consideration he gave to the question of which works to include, and for his advice in identifying the collections, the touring venues, and the writers that were all part of this undertaking. The writers deserve special mention for the insightful and unique points of view with which they have illuminated Will Gorlitz's ideas and practice. One final note of appreciation is to Alf Bogusky, Director General of KW|AG, whose support for the direction of the curatorial program continues unflinchingly.

Allan MacKay
Curatorial and Collections Consultant
Kitchener-Waterloo Art Gallery

kw|ag **KITCHENER - WATERLOO**
ART GALLERY

Acknowledgements

WANT TO THANK OUR PARTNERS, COLLABORATORS, LENDERS, AND supporters in this important project, which assembles, documents, and circulates to a national audience a survey exhibition of the work of Will Gorlitz. The exhibition was conceived and organized curatorially by Allan MacKay, Curatorial and Collections Consultant (KW|AG). Cindy Wayvon, Curatorial Assistant & Registrar (KW|AG), has been terrific in handling the many details of grant writing, loan scheduling, and overall project management of the exhibition. Assistant Curator (KW|AG) Crystal Mowry's advice has been invaluable throughout the project.

This project benefited enormously from the professional attentions of Judith Nasby, Director and Curator of the Macdonald Stewart Art Centre, who ably facilitated the publication with the assistance of Dawn Owen, Assistant Curator (MSAC). Bountiful thanks to Bruce Ferguson, Peggy Gale, Jeffrey Spalding, and David Urban, who so willingly took time from busy lives to contribute texts of lasting value. Appreciation is extended to Director Brian Henderson for his enthusiasm, guidance, and resources on behalf of publisher Wilfrid Laurier University Press, to Kathe Gray for her conscientious and astute book design, and to photographers Toni Hafkenscheid and Cheryl O'Brien.

Funding for this endeavour was provided by the Canada Council for the Arts and our roster of institutional funding bodies and sponsors. The tour of the exhibition has been supported

by a special grant from the Ontario Arts Council's Touring and Collaborations Grant Program.

On behalf of the board members, volunteers, and staff of the Kitchener-Waterloo Art Gallery, I am pleased to express our gratitude to all who made this project possible. We are proud and excited to be able to share this production with a wide national audience. Finally, I must express our appreciation to Will and our admiration for his considerable artistic accomplishments.

Alf Bogusky
Director General
Kitchener-Waterloo Art Gallery

 KITCHENER - WATERLOO ART GALLERY

Essays

BRUCE W. FERGUSON

Where There Is a Will There Is a Way

WILL GORLITZ IS A THOUGHTFUL PERSON AND A THOUGHTFUL painter. By that I mean that he does what he does with conscious deliberation and a full understanding of the limits and fragility of both the persona he has created as a person who paints and of painting as a communications genre with a vacillating role in today's culture. Gorlitz seems to lead a rich life, but it is one that is centred on a deliberate choice of both self-deprecation and modesty as limiting conditions in exactly the same way he understands the limited expectations that are the status and function of painting in general today. The reserve that serves him personally is at one with a medium—painting—which is most often considered to occupy a weakened or diluted register within the environment of contemporary communication media. In other words, Gorlitz is humble and humorous often, as are his works of art, but he could be anything else, given his deliberate and deliberating position.

As a result of embracing a relative position vis-à-vis the larger world, Will Gorlitz and the artworks he makes have a realistic heroics to them. The complexity of their making and installing, together with their materialized imagery, form a distinguished personal resistance to the potentially overwhelming effects of a dominant technological culture. Gorlitz has created a safety net of integrity in a tumultuous whirl of promiscuous image saturation. His is a kind of ecology of the mind. A quotidian hero.

When Stephen Smart wrote about Gorlitz's fellow artist and painter Doug Kirton, he correctly adopted the notion that Kirton was "using the landscape as a device to subversively infuse these images with contemporary cultural issues and values." One might say the same of Gorlitz—that his images and his clusters of images and his painting "installations" are also sub rosa image/texts for concerns other than those obviously floating on or embedded within the image surface. Gorlitz's works are, instead, intellectual paradoxes—even dilemmas—by virtue of being painted to articulate, in a powerful but cautious way, a way of seeing and registering the world more complexly and more ambivalently than is often assumed possible in painting today. This is a sly business on his part—painting passionately and prudentially, knowing all the while that the strenuous effort might be limited in terms of its reception. However, Gorlitz is committed to both a life and an art of knowing the pleasures of small details and deep things.

Gorlitz himself has written at least one confession/polemic about the sin or temptation of painting and his understanding of it. In it Gorlitz writes beautifully about the uncertain state of painting and its constrained ability to articulate the grand narratives also in an essay on Kirton, his close friend and professional colleague. In that essay Gorlitz names the condition and partial impetus for his own, as well as Kirton's, patience for painting—a practice seemingly in decline or, at least, often out of favour with contemporary criticism. His defence of painting falls into the condition or state of the modern world he identifies as alienation. In the essay, Gorlitz persuasively and passionately argues that alienation was a twentieth-century condition that afflicted both life and serious art. As such, alienation—in Karl Marx's famous definition, the alienated person acts as an instrument rather than as a social being—was the impetus for much useful cultural resistance, and Gorlitz uses the labour struggles as one example of this and the historical avant-garde as another. But, again persuasively, Gorlitz argues that today alienation is largely superseded, under post/modernism, by a hyper-alienation—an alienation so great as to seem as natural as the environment itself, like a precondition of all life. Passive alienation seems to have replaced the active alienation of historical struggles in the face of today's communications tsunami. Gorlitz, however, is not likely to give up active alienation easily as an impulse for working the way he does, for in it he sees the continuation of hope, even redemption, if one comes to terms with it—and continues to reject, on whatever scale, the tantalizing maw of globalism. This is not on his part a utopian vision but rather a smaller measure of possibility—not to change the world but to change a world. In a world now magnified or exaggerated—or "beyond beyond," as a new generation says—the term *alienation* is too simplistic and too clichéd to name this ongoing condition of daily and subjective unease, but its effects will not be erased if kept alive by the production of modest paintings that obviously still embrace it.

In other words, despite the lack of a suitable name, Gorlitz wants to play with and even accommodate a condition of being/not being in the world as a dialectic that can still be productive. And that dialectic is the one between alienation and centredness. As Brecht did with his "Alienation effect" (the use of counter-alienation to "make strange" by drawing attention to the means and the ends simultaneously), Gorlitz paints what he does and draws attention to how he does it in the name of the viewer as well as himself. In this way, he uses his own being as a node or a place which is centred enough to encounter the unreality of an unreal global condition through the possibility of mutuality. (The centredness or grounding is most clear in the *Axis Mundi* series, which is viewed from a deliberately deceptive perspective, created by the artist's situating the viewer in an uncomfortable point of view, often flat on his or her back and looking upward.) This is why Gorlitz uses installation as his framing device. Installation accounts for the incremental value of many of his works when they are seen grouped; they act as triggers to the ones beside or near them. By installing works that are relational one to another, Gorlitz ensures that all of his installation works of sight become works of site. This arrangement reinforces their artificiality and produces a realism of cognition as opposed to the illusion of appearances. He insists on being local to a moderate extent to unearth or to make transparent the global condition that seems to float everywhere like an ether we breathe, a condition that measures our distance from our own selves. By postulating a modest resistance—using what one critic called a "philosophical Surrealist" approach—Gorlitz reminds us of the untrustworthiness of the supposed condition of globalism and reminds us simultaneously of the intense intelligence within a local condition of knowledge. He is afloat in the "ruins of representation," swimming with his head above the horizon and his body deeply submerged.

His "bush garden"—to use another (un)natural metaphor, this one from Northrop Frye—is not merely Canadian and is therefore mediated through this national identification of specific metaphors. Globalization doesn't allow for that patrimonial sentiment of nationalism any longer, nor is it desirable. More complex than that, this new condition of cultural relativity allows Gorlitz to find an approach to art that is generic rather than driven by identity. He paints "outside himself" at the same time as he has a personal identity, but for him the personal becomes a foil rather than a fable, a façade rather than a feature of personality.

How did he get to this position and how is it possible for it to be effective? The trajectory is long and convoluted, and Gorlitz participated in it both consciously and as a result of factors and forces beyond his control. I will try to weave some of his work into a larger historical speculation that might help to position the work and implicate the painter.

At some points in the late 1960s and early '70s several social and intellectual forces coalesced dramatically, destabilizing and eventually undermining the

traditional roles of both artist and critic. In the process, the enduring narrative and institutionalized creation myth of the artist, the objectifying distance of the critic, and the agenda of the historical avant-garde lost much of their credibility and force. From a profound reappraisal of priorities in intellectual and political circles emerged different kinds of knowledge, different kinds of voices, and a different kind of cultural landscape. These forces included real-life changes like responses to the war in Vietnam, the waning of belief in totalizing political solutions, shifts in morality, the rise of interests in subcultures, single-issue politics, widespread pharmacological introductions, ecology, alternative medicines, and so on. Other, more intellectual, forces that weakened prior authorities were a combination of new identity politics, technological developments, and new intellectual critiques. Indeed, the relentless questioning of prior historical claims in general is the single most salient characteristic of our recent cultural and intellectual epoch.

The impulse toward interdisciplinary methodologies in universities is one example of the paradigm shift. Hyphenated discourse—for example, socio-economics and psycho-geography—records the uncomfortable reception of these combined influences in contemporary institutional framing. In other words, one word will no longer capture a discipline because the discipline itself is fractured into parts. This general interrogation of every discipline was fully ushered into intellectual and, equally, artistic life by the 1980s. It is clear that Will Gorlitz was propitiously placed when he entered this environment of skepticism and reassessment. At precisely the right moment and in precisely the right place he attended art school at the Nova Scotia College of Art and Design in Halifax—one of the few institutional hotbeds of change in international arts at that time. By that I mean the college made radical changes to its curricula expressly to accommodate the radical ideas that were circulating in the art world worldwide. It was post-national and postmodern before either of those terms became widely used.

The trajectory outlined here as it manifested itself in art and its worlds arced from a belief in the *autonomy* of the work of art under modernism and its narrow terrains to a belief in the *context* of a work of art under the new wide and inclusive "post" conditions. Under various rubrics—post-feminism, post-colonialism, post-structuralism, postmodernism, and so on—considerations of the conditions of art-making, including representations of different standards or qualities from different cultural sources, were now being taken seriously and even assumed to be necessary for production and interpretation. Not only could a work of art not be autonomous under these new umbrellas of knowledge, it must bear the impress of its maker and making in a politically and socially understandable way.

On a more personal level—and one that I feel Gorlitz has particularly exploited in his understanding of coming to make a painting, or, more generously in his case, a work of art—the notion of the artist as an individual shifted dramatically as a result. Unlike the former authorial view of the individual genius artist, the "post-individual"

artist (and often post-studio artist) was now understood to be a container of con-flicts and contradictions that worked *against* the condition of permanent identity. In addition to the familiar divisions of the language of psychology (subconscious, id, and ego, for example), the previously comforting narratives of social, familial, gender, national, regional, or sexual identities began to be discredited as unstable, fragmentary, unfixed. And Gorlitz I think embraced this newer notion of the radically unstable identity. Identity came to be understood not as stable and predictable but as a series of affiliations of every kind, changeable at the turn of a scalpel, the click of a mouse, or the hiring of a spin doctor. Identity could be taken on, acted out, cre-ated. Not stable but in process or motion at all times. In the words of the Bolivian artist Carlos Capelán, "Identity, far from being a question of 'essence,' is basically a matter of strategies." And at the Nova Scotia College of Art and Design, the tactics for making art that emerged from the embracing of various forms of conceptualism started to dominate, even more than strategies might do, as the most viable meth-odologies—again, not as the essences of any personhood but rather as conscious actions and decisions to promote a renewed viability for art. Tactics, I understand to mean, with Michel de Certeau, are "calculated actions determined by the absence of a proper locus ... operating by isolated actions, blow by blow ... taking advantage of opportunities.... What it wins it cannot keep." This sense of tactics is what all good artists at NSCAD learned, and, I would suggest, it became a wider ideological basis of all significant postmodern work worldwide.

The foregoing account is a highly abbreviated and simplistic history of a complex and subtle historical, and in Gorlitz's case, subjective process that took years to play out and that played out differently in many places simultaneously. But it acts, I hope, synoptically to register a significant mutation and transformation—a kind of line-in-the-sand moment in culture. The art of the modernist past was often assumed to be handmade by an individual with specific motivations, and it was often accompanied by critical interpretations based primarily on those subjective intentions and emo-tions or along straight ideological lines (the historical avant-garde or formalist, for instance). The shift I describe chronicles instead a culturally based production of art, often narrative in nature, with orientations to audience engagement and complex contextual interpretations. If identity is mediated, not natural, then the products of identity are also mediated. This conclusion leads Gorlitz, like others, to approach painting conceptually, tactically, and by "withholding judgment" (his term) to see the artwork as a cultural product outside of himself. Painting, rather than "representing" (re-presenting) something, became instantly a representation of a representation. An echo of an echo already heard. If "conceptual painting" exists, it exists because of this moment and the absorption of the lessons therein.

To illustrate the influence of the changes that had such a powerful impact at that time, one example might suffice. One of the most important impresses in the art of

that time was related to a literary and philosophical debate—that of the so-called "language turn" or "linguistic paradigm." The language used about art in these years overwhelmingly relied on recourse to other disciplines. Whether curators or critics invoked philosophy, psychology, literary or semiotic theory, or identity politics, their language was often a transcription of someone else's—the phenomenon of what Harvard academician Marjorie Garber calls "discipline envy." And I don't mean quoting or referencing here; I mean incorporating whole other disciplinary vocabularies into the discussion of art objects. In its most extreme form, the borrowed intellectual apparatus overwhelmed the works they described—their relation to those works was that of a fantasy to a fetish object; textual exaggerations were the consequence. This migration of literary theory to the artworld began to produce a whole new role for language in relation to art.

For instance, the exhibition in 1969 entitled *January 5–31, 1969,* organized in rented office space in New York City by Seth Siegelaub, stated the new premise precisely: "The exhibition consists of the ideas communicated in the catalogue: the presence of the work is supplementary to the catalogue." A rhetorical gesture, deliberately exaggerated and extravagant, actually became a predominant dictum for many artists (and then curators). The conceptualism that the catalogue attended became predominant as a mode of art; similarly, text became dominant as art became subordinate.

And for a large proportion of at least two decades, the institutional artworld manifested this primacy of texts over objects. The power of "theory" may have begun with that exhibition in 1969, but its increasing institutional power continued unabated and punishingly. The primacy of text over object may be seen in the Boston Institute of Contemporary Art's *Endgame* exhibition in the mid-1980s, where the exhibition catalogue featured the names of the theorists writing for the catalogue and not the names of the artists. Exhaustion probably set in in 1989 with the Los Angeles Museum of Contemporary Art's *A Forest of Signs: Art in the Crisis of Representation.* This exhibition's oxymoronic title expressed nature's and art's final reduction to language—the natural and the artificial as semiosis only. At this time, at an institutional level, the material excess and unfathomable nature of objects and images began to reassert themselves, although they had been kept alive in artists' practices everywhere.

Gorlitz's relation to language has always been careful. He understands both the reciprocity and dilemma of the relation between art and language. He exists somewhere in the oscillation between the two extremes—that of language as the ur-cultural value and of painting as somehow personally expressive regardless of content. I think Gorlitz understands that it isn't a question of whether language is being used to understand works of art, because we know artworks don't speak by themselves. They swim in the sea of language before and during and after production. The questions that arise instead are what kind of language, how much language,

and to whom are these languages addressed? Which institutions of language are being utilized and for what purpose?

Earlier in the twentieth century one of the emblems of modernism was an abstract work of art—often a painting—still connected to a grand humanist tradition emanating from the Renaissance. Abstract paintings of the twentieth-century continued from the earliest through to the paintings of artists like Brice Marden or Robert Ryman today, which are highly regarded for their "touch"—the hand of the painter evidenced in the brush strokes as, say, an index of sincerity or subjectivity. The individuality of the painter in such works is seen as the defining and determining quality of the art. And there will always be something to be said for the materiality of painting and the meaning that paint produces beyond its representations. But through the new lenses of theory discussed above, those abstract paintings started also to be seen as representations of a particular sensibility, of an individual, and of a particular notion of a human subject in history and of the underlying ideology or ideologies. Thus, works of art are now seen to be as mediated as the personalities that mediate them (although the romantic view of the subjective individual artist is still adhered to by the marketplace in particular). We see retrospectively, then, how "abstractions" were inscribed as representations of subjective freedom, and thus even national interests. Contextualized, abstractions had many meanings beyond the artists' intentions and beyond a single artist's biography. The relationship between abstract expressionist painting and American cold war politics has been persuasively demonstrated in Serge Guilbault's book *How New York Stole the Idea of Modern Art* (1983). Institutions of framing—museums, criticism, the marketplace—were factors in what became to be known as "reception theory." But, importantly, if all communication is representational in some way, it is circular in the sense that the chicken-and-egg question is circular: they are arbitrary signs and one can't go back far enough in history to discern the origin, only the uses and histories, and none of these are unique.

In a very real sense, aesthetics were taken off the table—which put "art" in a very disturbing and seemingly unnatural position, given the close association that art and aesthetics have always had. But aesthetics were now posited as highly exclusive and therefore politically reactionary. The celebrated aperçu "Painting is dead (long live painting)" was an instant response to this particular historical moment. But eventually it started to be understood that, as Patrick Horrigan has written, "indeed, painting cannot mean what it once meant ... when painting was universally and enthusiastically put into the service of religion and politics[. B]ut *painting cannot be forgotten*, and it continues to appeal to millions of people (as does religion)."

In other words, although theory appeared as an overachieving exegesis of art, an oppositional position with regard to language began to emerge as a counterforce to

the academic hegemony. For instance, as Stephen Tyler writes, "To represent means to have a kind of magical power over appearances, to be able to bring into presence what is absent, and that is why writing, the most powerful means of representation, was called 'grammarye,' a magical act. The true historical significance of writing is that it has increased our capacity to create *totalistic illusions* with which to have power over things, or *over others* as if they were things." The capacity for language to seduce, to create illusions, even to lie or slip through logic and regulatory systems itself, slowly came to the fore as the pendulum swung back. Language was not totally trustworthy. And language therefore is and has an aesthetic.

Eventually it was seen by some that indexing a critical theory was tantamount to articulating an oppositional politic. When such critique became a growth industry, as it did in the last decade through institutions such as museums and universities, its ideological critique was seen to be insufficient—depoliticized, a mere mirror to preserve the balance of power. It was oppositional debate without opposition in fact. It suffered the unavoidable co-optation that accompanies popular trends anywhere, just as the avant-garde became what T.J. Clark has called "the bad dream of modernism."

And the relation of objects to the mastery of languages, of course, is the relation of things to the critic or curator, by virtue of language. Arthur Danto has recently made the claim that the Pre-Raphaelites ushered in the modern period. He indexes their non-aesthetic innovations. They "invented the hot artist, the art movement, the breakthrough, the press release, the manifesto, the buzz of sensationalist openings, and the idea that art must be set on a new path," as well as—through the words of John Ruskin—the invention of art criticism as promotion. As Danto puts it, "you need look no further than Ruskin for the origins of ideological art criticism, which announces the direction art must take and denounces art that doesn't take it." This is the power that language and language networks seem to have over mute things. Or potentially have. Or not ...

For Gorlitz, the unrelenting position he has adopted is one of acknowledging an ongoing dialectic between images and languages. This acknowledgement of the dialectic between images and languages began early in his career and seems to be one of the most important driving forces in his creation of imagery and the obligations brought to bear upon them. This dialectic found one of its earliest manifestations in *Certain Terms,* a series of painted images on individual pages of Raymond Williams's famous book *Keywords: A Vocabulary of Culture and Society* (1976)—a prodigious attempt to provide a cultural etymology of significant terms in the history of culture. In the series Gorlitz wilfully interrupts the definitions and histories with somewhat arbitrary images, smearing, as it were, the literary efforts with an imagistic one (or is it the other way around?). In this series of works, we don't have illustration

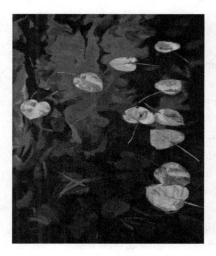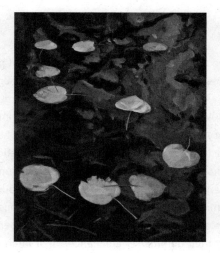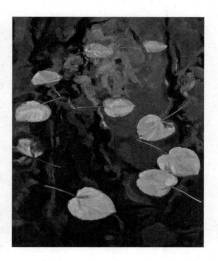

(which would have provided a comforting narrative of one-to-one correspondence) but rather a kind of secretion of one discourse into the other, a viral disruption discharging meaning in too many ways. Gorlitz has always spoken about painting as a kind of speculative or even fantastic endeavour, and here in particular we see what he means. It is not the painter or even the esteemed academician in this case who can determine meaning—who can separate the combatants. It is you and I—the viewers who are driven to a kind of conscious decision-making state by the dilemma—who have to take up that task.

In *The Distant World*, language or media, in the form of reflected international newspaper titles in the liquid of coffee cups, definitively confronts our expectations of painting and of media. The paintings were hung at an angle above the viewer's eye level, slightly menacingly, definitely askew, and then in the first instance of their installation accompanied by newspaper clippings seemingly random. The conjunction or confusion of media both within and without the frame link the paintings to the so-called real world at the same time as they comment on media ubiquity, but the coffee cup acts to remind us of a world of intimacy, of time spent in contemplation or reading, of tastes and sounds not covered by the media. Many worlds or world views are simultaneously made available and painting is given a precise role in the series of interconnected communication links. Again, linking language or words to their arbitrary status as a "floating signifier," Gorlitz has painted *Literatus with Vessel* or *Literatus with Flames*, where the language of individual images sits or floats in a natural surround. Even in his *Numerals* series he has painted leaves that float "innocently" on the surface of a liquid in a decimal sequence of zero to nine, which inevitably evokes in us the unnatural language of mathematics. These takes on "language," by respecting language, representing it, and undermining its regulatory authority simultaneously, are creative dilemmas articulated, the very creative dilemmas at

the source of production and reception of painting. All are contrivances, theatrical presentations of ideas, transactions in action, and incomplete. The light touch Gorlitz uses visually disguises the weighty and fraught discourse that underlies each.

What this amounts to in painting, as in any other medium, is that we have become very aware that speech—or articulation of any sort (language, images, and so on)—assumes a different dimension of conviction depending on where it is spoken, by whom and to whom, within which medium of diffusion, and under what circumstances, regardless of the arbitrary so-called objective rules of language. We have similarly become aware that the meanings of paintings, sculptures, photographs, installations, and architectural spaces depend upon their social context and histories for their dominant significance. Their intentions are one thing, their results another, as with most communication. They misspeak and we interpret badly or in error, at the very least. Importantly, we have become aware in this all-pervasive environment of languages and signs and symbols and icons and texts and a huge array of visual and textual stimuli that it is we who decide what to believe and what to reject. Meanings radiate from a slice of a medium, but we determine which ones are viable and which have discursive longevity. We calculate the amount of distortion or noise as truth we wish to embrace.

As I wrote in *Notes on a Local History* for the show *Toronto: A Play of History*, in 1987, "meanings of art, like all meanings, are socially produced: a result of collaborative interests and counter-interests, social constraints and complex interrelationships" that give rise to "continual revision of meanings according to, for instance, historical moments, speakers, ethnicities, genders, contexts of reception and so on." Which is just another way of saying that there is meaning only within context. Nor is any context stable; it is just an arbitrary way of doing things right here and now.

Another release from the autonomy of modernism is the way in which some aspects of modernism are now pursued as subjects rather than assumptions. Even in the more conservative area of painting, recent work of a younger generation like Gorlitz's was foregrounded by the paintings of Gerhard Richter. His painterly career has been distinguished by a tension between conflicting ideas; he works with paintings that range from the romantic figurative vocabulary positioned against paintings made of details from romantic abstract paintings, all of which proceed from photography. Richter's reception in many ways depends upon and critically comments on the dichotomies between figurative and abstract. The artist Richard Artschwager, throughout a career beginning in the 1960s, has similarly reframed the formal considerations of abstraction within figurative objects and images. The wry humour and irony in his work inform the emotional distance of the next generation's work, and certainly his "blips" and other blurs of exhibitionary displays have had a direct influence on the painter Gorlitz.

Will Gorlitz: nowhere if not here

And there was of course a whole array of artists of the last two to three decades for whom language is the physical material subject as well as the expression of their aesthetics and cultural politics. They range from Lawrence Weiner to Barbara Kruger and from Jenny Holzer's LED signs to Ken Lum's image/word juxtapositions. Museum labels are a medium to Jac Leirner, and Carl Andre's drawings made of words or Robert Smithson's are other examples. Bruce Nauman's anagrammatic neon sign puns are one other example and Lyle Ashton Harris's mix of statements from porno texts together with the theoretical statements of Stuart Hall are another. Even in painting, in the work of David Diao, Nancy Dwyer, Ed Ruscha, language is an acceptable subject of vision.

Gorlitz's direction is constructed and completed differently, however. Gorlitz did not so much use language as a subject of art, however useful that had been to other artists, as much as he used the "presence" of language, or one might say its omnipresence as a hovering ghost always about to erupt into the image. This is demonstrated in his remarkable series of works entitled *Three Essays on the Theory of Sexuality*, in which he takes on the legendary academic and pop culture figure Sigmund Freud. The series of sixty-three drawings is a visually complex articulation of a mediation of a mediation of a mediation, at the very least. Freud's photocopied text (a duplicate) is in English translation (and any translation is, as Walter Benjamin says, always traitorous) and is deliberately marred by images (quotidian but often "Freudian," as in the mixed-fruit compositions, as *Freudian* can nearly always be used euphemistically) on a text which is allegorical and metaphorical by nature, relying on images as a form of therapeutic knowledge. The pun begins. Jerry McGrath in a brilliant essay on this series calls the images chosen by Gorlitz a "promiscuous conjunction," which acknowledges that Gorlitz, like a patient of Freud's, can be both unconscious and conscious in his choices. Like Freud and his patients, like Gorlitz and his linked desires, we want there to be meaning and, like the way in which we are prepared to deal with a Rorschach test, implied meanings are there to be derived. But, like the "science" of psychology, these paintings are all art, all interpretations, not facts.

It was Marcel Duchamp, who in 1957 told a meeting of the American Federation of the Arts, in Texas of all places, that although "the artist may shout from all the roof-tops that he is a genius, he will have to wait for the verdict of the spectator." And it is this idea of art being complicit with and implicated in discursivity in a public sense that now has vaulted the walls formerly maintained by elite and elitist culture.

As well, Gorlitz, like many others who came through the postmodern moment and took it seriously, understands that images, like language itself, are *generically duplicitous*. As Janet Malcolm says, "Of course, there is no such thing as a work of pure factuality, any more than there is one of pure fictitiousness. As every work of

fiction draws on life, so every work of non-fiction draws on art." The always present danger is that any lingual sign may be used to lie, to tell a fib, to claim a dishonest space. As Gustave Flaubert says, a sentence is only an "adventure." In Harold Bloom's terms, a sentence is only a "map of misreading." Even in its exalted forms of "literature" and "science" and the "law," any sentence or language fragment that proffers to tell the truth, as Umberto Eco says, can offer the same sentence as a lie. And of course images do the same kind of ambiguous work. A decontextualized photograph is not worth a thousand words in a court of law but actually it needs a thousand words to tie it back to the world and a specific context to make robust meaning. And a jury or a judge to determine its "truth" value.

So, although language and writing became privileged within the visual arts—and still are, in provincial understandings of imagery and objects—there also arose, eventually, and perhaps predictably, an equally strong resistance to that position of privilege. This resistance seems to me to be based on the understanding of language's lack of neutrality. The *resistant nonlinguistic* is what in ordinary language might simply be called the physical world—the world of the visceral that generically resists full linguistic appropriation. The material world is always an erotic body that ceaselessly and carelessly crosses the disciplines defined by language. And eroticism, as the T-shirt philosophers and situationists always tell us, undermines authority. And for Gorlitz, and others, painting in all of its messiness and its uneasiness is one of those resistances.

The dilemma that confronts any artist, curator, or critic today is that there is no space external to language, or theory, and yet there is the knowledge that language is an eminently suspicious and unreliable measure of reality. The non-linguistic, when it is positioned as art, does just this; it resists language for as long as possible, avoiding the inevitable grasp of language's eager clutches. It clears a space between the language that determined it and the language that it will help to determine and which will then redetermine it, like this text. The space between the before and after of language for Gorlitz is painting or at least painting installations. It is one of Gorlitz's goals and it manifests itself in many ways, but the most important is the exhibition—a form of articulation that normally and normatively frames works of art. To maintain the unease that many of his single images contain internally, Gorlitz undertakes to create painting "installations," an exhibitionary way of de-framing the gallery or museum itself to let the images work, sometimes through repetition, sometimes through interruption, to create a viewing space unlike the Renaissance space that positions the spectator as comfortable overseer. He also clears himself of a systematic recognizable artistic style by creating each installation individually in terms of number of images, exhibitionary tactics, and medium or media crossings. He has neither identifiable style per se nor subject matter per se. Instead, he foregrounds the display of works of art and, in doing so, encourages the meanings

to be read out by a public confronted with the honesty and rigour of theatre—of the effects of representation.

Interestingly, the conceptualist argument for a linguistic work of art as privileged over the visual or the anti-aesthetic that accompanied it did not inherently lessen the interest in and desire for aesthetic experiences motivated by encounters with images embedded in materiality. There seems to be a continuously large social and psychological need for objects as strange signifiers—a need seemingly deeply ingrained, perhaps primal. This need—almost an ache—for an *unreasonable* object—a material and visceral body—outside or beyond the reach of language still seems to create the impetus for much artmaking and of course its potential receptions. Gorlitz has eschewed the calling card of individual style for the knock on the door. He is a master of the unreasonable object—the image and the installations that won't quite do what they are supposed to, like an unruly child with a will of its own.

The other factor in the change to a new and different concept of art is the increase in the use of technological ephemera—mass media systems of production and consumption. Over and above theory and migrations of theory to art there were tools of communication that altered the terrain for art, slowly at first and, over the past two decades, with unanticipated speed. Even earlier, real attempts to contain photography in a realm of its own, separate from the higher orders of painting and sculpture, for instance, collapsed. In fact, the saying that photography is today's painting now has much purchase. Until recently, it was often believed that photographs "captured" their subjects. This misguided belief—philosophical, psychological, and technophilic—produced the myth of a photographic objectivity. By conjoining the instant to the infinite, it was said, these prosthetic eye machines called cameras sustained reality by looping seconds to eternity. One of Gorlitz's funniest responses to this discourse is a simple image entitled *As It Is*, the image of a 35mm camera submerged in a watery bed. In *Not Everyone*, Gorlitz's portraits (of anonymous passersby viewed from above, from the position of the urban surveillance camera) attest to the camera's already ubiquitous political and social use. Recent studies in photography and artists' uses of it have completely undermined the earlier belief in objectivity and evidence, just as language has been undermined. We realize now that photographic images tell us little without a caption, as Bertolt Brecht explained, or at least without a language complement. Gorlitz's sly allusion to the camera in many of his works or his strange and unlikely technological support in the self-portraits of *Bad Faith* make us aware of his nod to and acknowledgement of being implicated in the new technologies. This is extremely clear in the shattering vases paintings (with their specific affirmation of high-speed photography), but they are doing other work too.

Each visual clue—a painted image or a photograph, in science or in art—seems now to trigger questions larger than the answers it might have seemed to provide. Such is the nature of art and its interpretations in a skeptical age. Simply put, a

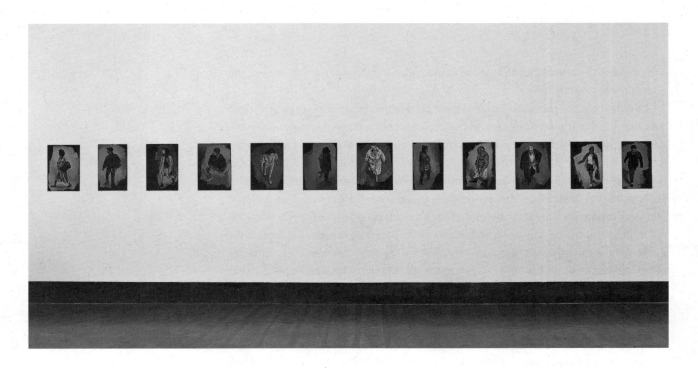

Not Everyone (installation view of selections from the larger series)

photograph—in a sense analogous to the image of Christ that appeared from a religious impulse on the Shroud of Turin—is actually an unstable object in a legal case or an aesthetic controversy or a political filibuster. A contemporary photograph, like its spectral ancestor, is an uncanny object—almost magical the moment it appears—however legitimate and scientific its ambitions. Its ambiguous appearance spurs many stories and debates rather than logical conclusions. This is no less true of paintings or any evidentiary document. In other words, to see is not to believe but to be beguiled, bewitched, bothered. All images, and particularly paintings by virtue of their making, are transitional objects, begging for a certainty that can't come, a stability that their own materiality contradicts. Gorlitz plays in this ground of disengaged, unmoored activity.

This use of technological forms of communication by artists—whether directly or by implication—is long-standing, and it threads its way through modernism, particularly with photography but now with even newer forms of image/text communication. But, again, it is in the past thirty years that these forms have crept like skeletons from the closet into the drawing rooms and salons of culture. A respect for what Simon Firth calls "low theory" has made the definitions of art and its sites of meaning more and more vernacular. Andrew Ross has elaborated this in relation to artists who came of age during the introduction of television. He says that they are "the first generations to *use* their involvement with popular culture as a site of contestation in itself, rather than view it as an objective tool with which to raise or improve political consciousness." This tendency is in opposition to "the last generation of American

Will Gorlitz: nowhere if not here

intellectuals who swore unswerving allegiance to the printed word and the dictates of European taste."

Modernism was resistant to any construction of culture that was inclusive. But, as Antonio Gramsci says, "In the realm of culture and of thought, each production exists not only to earn a place for itself but to displace, win out over, others." The conflict between abstraction and figurative representation is an exemplary case of such competition—a cold war that has resulted in a postmodern détente. Further, the importance of this for art is unquestionable, as Andrew Ross suggests in *No Respect: Intellectuals and Popular Culture*, because "the struggle to win popular respect and consent for authority is endlessly being waged, and most of it takes place in the realm of what we recognize as popular culture."

And I spoke of modesty. In theory, that is theory as a discipline, art is all over. That is, art has ended, died, and should be given a proper discourse burial. Writers from Donald Kuspit to Arthur Danto have published announcements of its demise and offered obituaries. Other critics and cultural writers think that art today is increasingly debased and compromised—not quite dead—but they abhor its present status, associating it exclusively with entertainment, luxury markets, and a dreaded capitalist conspiracy. That it will die soon is their diagnosis. It is tarted up in its many commercial disguises and has no single purpose and no overarching goal. It mixes promiscuously with popular culture, fashion, media distributors, and the rich and famous. It is too inclusive to be serious.

The announcement of art's death or its kitschy double's descent into discourse hell is an intellectual one and it is in direct and inverse proportion to art's highly visible appearance on every scene. In the other position—that of the wide variety of practices of artists—art is quite clearly ubiquitous in the more quotidian sense. Art as a practice, an object, and an experience has never experienced more attention or more status. It is in use everywhere from luxury markets to therapeutic workshops. It is primary in acting as a kind of cultural ambassador and within transnational exchanges of understanding. A message on a Starbucks coffee cup reads, "In an age when pictures have become more eloquent than words, schools are still programmed to reduce the child's immersive interaction with the visual world to the practical poverty of the alphabet. Visual literacy should become a pedagogical priority in order to prepare our children to function within the increasingly visual complexity of our environment." That is a quote from the Brazilian artist Vic Muniz. In the new Net world of nodes and near nomads, art is one of the first places anyone goes to secure a relationship to the foreign, the strange, the other. Art is a common denominator of everything from wealth to new nomadic cultural interactions. It is the key and it is the bridge to a new world view.

However, even if its role is diminished or diluted, or in bed with popular culture, as it often is, there are many instances of art still working, still providing epiphanies

and experiences out of the worldly. To paraphrase Donald Kuspit, high art may have spoken to the happy few, but today it speaks to the unhappy many.

But this is not to say that all art is public. Public art is meant for what Mark Roskill calls "unprivileged viewers"—the uninitiated or the under-initiated. And conversely, there is art made for and discussed by "privileged viewers," as we know, because we are them, to quote Walt Kelly. We are those who have means of access not readily available to others. But we know that works of art, public or not, do not speak entirely for themselves. Any kind of art on the trajectory between public and private depends on the rightful assumption that artmaking is social, even if it was highly subjective in origin. In other words, productive art has always both a personal significance *and*, to be meaningful, a strong connection between that subjective meaning and social forms of communicating. I think we all know, like Duchamp, that if a work of art is ignored, there will be no art in any robust sense. But if someone—someone motivated and, often, loud enough—takes it up, it can be viewed in considerable light. There is an *art discourse*, as opposed to an art history (which is disciplinary in the punitive sense), and this discourse is, in Foucault' phrase, "the ensemble of the phenomena in and through which the social production of meaning takes place." *Art discourse* seems a better name for the practices and institutions that slowly constitute art or its histories and which take up the work of art.

The irony, perhaps, is that art itself is today part of the promotional culture, part of popular culture. It is part of a popular discourse as well as more arcane ones. And as usual, artists' practices are perversely aberrant from the technological purposes of production. Painting has its place, as does photography and video and so on, by virtue of its distribution systems as well as its systems of production, and "doing the knowledge" as Gorlitz does by painting and interrupting the dominant texts of culture is just as valid as any other medium. Knowing that all media are motivated—are vying for audiences by demonstrating their rhetorical persuasiveness—makes one medium no more or less provocative or useful than another.

Jean-Luc Godard—the mercurial artist of filmic thinking who uses language as image, image as language, and every device in between to avoid any easy categorizations—is a good example of the same promiscuity outside of painting that Gorlitz displays within. Godard has created the possibility of a material criticism and a restless oscillation between and among forms of communication: words and images, cinema and video, documentary and narrative, imaginary and realistic. But it was Godard himself who famously realized, after the fact, that in trying to make *Breathless* as a realistic genre film in the film noir mode, he had in fact made *Alice in Wonderland*.

This element of the unforeseen parallels Gorlitz's understanding that painting is speculative and always a bit fantastic—and certainly unpredictable. It is his sense that there is industrial time, digital time, prehistoric time, and other time frames, including presumably subjective or psychological time. And painting is a medium

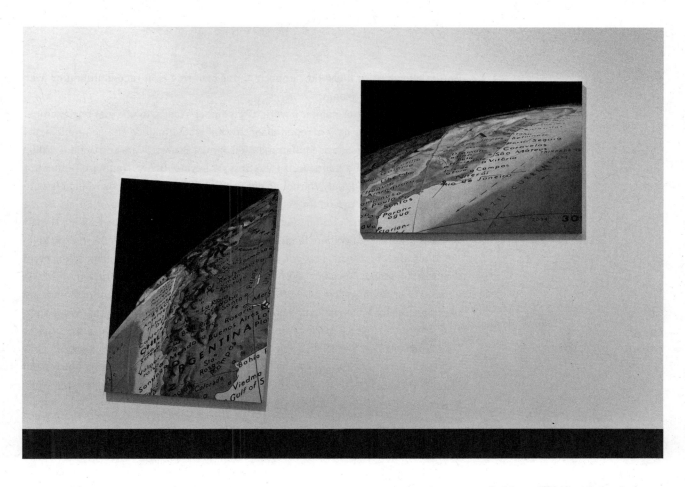

Peripherum View I (installation view)

that can make use of or address these times and even simultaneously—one of its real virtues. And this is the true agnosticism of today's art: an understanding that the tales that are used to motivate are interchangeable and peripatetic. When Gorlitz splits a screen as he does in his highway paintings or his map paintings, it is not just a formal device (although it is that, too, as it might be with Godard); it is also a cognitive device to arouse dissonance deliberately and create both a literal and a psychological gap so that easy gestalt is not available. By forcing the viewer into active completion, the paintings, alone or in collaboration with others in installations, occupy an uneasy space of anti-logic. Separation—and near repetition, both of which are characteristic of Gorlitz's best work and best installations—is no mere idiosyncratic style, any more than the separation of sound and image that a Godard or a Kovacs might use. Crossing us up, as these anxious methods do, reminds us of the imperfection of any communication, no matter with what integrity it is composed or delivered. It reminds us of how much we want the simple, the ordinary, the stable, but how dishonest it is to pretend that they exist. The images are all nomadic, and by admitting this before their travels to other spheres, before they link to new meanings,

Gorlitz allows us to know how important our own role is in reconstituting or even reimagining these meanings.

If I look at another painter's work, Christopher Wool's, to use just one example, I can see influences as a mapped diagram that would include the aesthetic activities of names as various as Muhammad Ali, James Brown, Jean-Luc Godard, Philip Guston, the Fugs, the Lounge Lizards, Sherrie Levine, Bruce Nauman, Dieter Rot, Martin Scorcese, and Andy Warhol, to name a few. His word paintings would be more strongly connected to and inflected by the linguistic productions of Lenny Bruce, Spoonee Gee, George Clinton, Jenny Holzer, the Last Poets, Public Enemy, Hubert Selby, Big Youth, and William Wegman, for instance. But it is not simply in expanding the kinds of comparisons that does such artists some interpretive justice. It is more that in abandoning "straight" discourse, the "queerness" of a hybrid complexity is allowed to breathe and we are better able to come to terms with what meaning is at all times. Gorlitz's list would be equally diverse and polymorphous, containing theorists, Patterson Ewen and David Milne, garage bands, courtroom drawings, Timothy Eaton, parables in the Bible, cartography, Carl Theodor Dryer, Laszlo Reny, and others. Meaning that not only have the barriers between and among media blurred but that there is an admission today that artists, as scavengers, use any and all means to create forceful imagery and spaces to be convincing in thoroughly promiscuous ways.

Such work coincides with Andrew Ross's description of other work complicit with popular forms: "Committing critical speech to common, vernacular ground doesn't mean giving up politics, only a sacred, theoretical attachment to political essences." Artists actually demonstrate now how any rhetorical device, popular or arcane, can be personally embraced and used as a one-to-one system of communication or a one-to-mass system.

Artists such as Gorlitz participate from the neglected spaces *within* established traditions. Rather than trying to continue an avant-garde agenda of introducing experimentation for its own sake, his generation works knowingly complicit with commerce, for example. In other words, at the beginning of the twenty-first century, artists are coming to terms with the "effects" of representation while continuing to produce objects and spaces that invoke and provoke earlier, more formal, characteristics of a pure modernist project. Such work does not reconcile these differences but rather foregrounds them to establish a revitalization of the modernist project itself. Impurities, references, associations—these are encouraged, or at least not ignored, in the works of these artists. And their works are often just as at home on the floor, on a shelf, or hanging from a ceiling as they would be on a sacred museum wall. They are also at home on billboards, television monitors, or LED signs in Times Square.

Another impulse during this time, which is not yet encouraged in Canada, is the past two–three decades of acknowledging at an institutional level the contributions of major movements outside the dominant centres of power. Lygia Clark and Otticia as well as other Latin American modernists are now being embraced within a larger understanding of cultural and critical understandings of today's art. This revisionist impulse is felt everywhere today and does much to recover the marginal to the centre as a method of global understanding. Exhibitions such as *Abstract Art from the Rio de la Plata*, at the America's Society in New York, exemplify the new trend to grasp what was neglected in modernist narratives, in that case the wonderful work in Buenos Aires and Montevideo from 1933 to 1953. If Canada were ever to mount such an attempt to tell the story of modernism from within its semi-colonial positioning and posturing in modernism, the stories would have the same truths and strengths as those in the Latin American discourse, which has moved from invisibility to canonization within three decades. And Gorlitz of course would be a chapter in one of those tales.

I mentioned his humour. And today, ultimately, the new space that he occupies is often both playful and serious. His activities do not stem from a need to justify a tradition within a medium, nor might he attempt to address a narrow set of historical questions within a critical discourse. Instead, like all contemporary artists of quality, Gorlitz accepts that his influences and directions are linked in circuits that radiate outward to films and television and other popular arts, to literature and other discursive systems—advertising, politics, sports, news, music, and so on—all mediated through language and photography. Art exists today within what Richard Prince calls "wild history"—subjects of the webs of intertextual meetings of discourses and disengagements, of dislodgings and discernments.

Today we have interventions rather than positions, spaces of mutuality rather than exclusion, discursivity rather than textuality, tactics rather than strategy. Because works of art precede theory and interpretation, artists and critics and curators are more careful now not to embrace theory out of insecurity and risk prematurely suffocating the works and their meanings. The postmodern conditions we look for in works of art—contradiction, heterogeneity, and multiple uses and transitions of styles and media, genres and techniques—do exist. But in acknowledging such works, we have to be careful to acknowledge the provisional condition of the meanings of works of art. Gorlitz asks us to do this—indeed, he carefully demands it of us. He is saying at least on one level that if he is exploring the materiality and subjects of contemporary life in manners, methods, and media, our obligation, then, as writers, readers, and watchers is to understand the complexity and the aesthetic and social richness of his imagining more responsively and less categorically. And he is saying that it is important that we do so.

It is important because we now know that artworks incorporate both memory and identity, and this connectivity is central to large segments of many societies. It's why we care about the appropriate memorials for victims. Or why we sometime actually measure whole civilizations by the nature and presence of these works— thus the rightful outcry when cultural heritages are appallingly destroyed or pillaged, as in the recent invasion of Iraq. And we also care about the quotidian things that constitute the artworld. We care when money changes hands and which people are appointed to positions of power. We care about whether public monies are spent on Jana Sterbak's meat dress or on a Barnett Newman painting. I suspect that we don't think that art has the power to change anything structurally very often (but think of Le Refus Global as a major exception), but we know that art has the power to create and sustain consciousness that affects the will to change. We know, and know well, that artworks mean more to us than we know.

Today's artists work from a very highly charged space—a media-ized space where all things are seemingly visible—and they cannot simply adopt the (now) highly conventional and comfortable view of art's role as critical, repeating endlessly an avant-garde litany without interrogating its patrician and even aristocratic rituals of difference. So the question now is how to make art that is critical if desirable as well as understanding that the landscape of art has changed in such significant ways that single aesthetic or ideological positions are not acceptable, desirable, or useful to a productive and creative life. When they are good, they are still uncanny objects, and they spur many stories rather than logical conclusions, and that is one of their strongest values.

If context and audiences today make a work of art work (as opposed to good intentions or proper political positions), the art world for an artist like Gorlitz is clearly half full. There are simply more contexts to work in today. Opportunistic artists, optimistic or not, by not adhering to any single ideology or medium or even desire, can surf the world for contexts and within them search for moments in which they may be effective. Sometimes, it is in the most conventional site, such as a museum, and sometimes it amounts to hiring a plane to emit floating messages. Sometimes it is a biennial and sometimes it is the most intangible performative work possible—like a Tino Seghal kiss performance—and sometimes it is in a commercial gallery where a viewer has an unexpected epiphany. Regardless, the best and most interesting work being made today seems to me to be governed by a guerilla approach which has little regard for anything but useful material and historical information, strong aesthetic and imaginative knots, full understanding of the context of exhibitionary moments and respectful approaches to audiences. These are artists today, like Gorlitz, I hope, who do not resolve contradictions but prefer a both/and approach to the world rather than an either/or. As a result, their "success" is both a possible and a useful model.

Often now called "relational aesthetics," participation is not a by-product of this art but the driving force behind the creation of a new dynamic open system of "art." Social spaces are no longer believed to be neutral but are animated and inhabited by people, memories, and representations that are themselves not passive but participatory and contingent. In short, installations and performances (sometimes by objects alone) have emerged as a new art form with an emphasis on public spaces as the stage and positioning of meaning. This shift is toward a culturally based production of art, often narrative in nature, with orientations to audience engagement and complex contextual interpretations. This is also, as it were, a shift to common sense and an understanding of the role of reception in meaning.

If Gorlitz's wit and commitment are as thoughtful as I think they are and are evidenced in his work (by which I mean individual works of art and their many and varied exhibitionary projects) as I think they are, then what we are seeing here is an evolutionary moment of individual heroics and, indeed, progress of the head to the hand to the head in a vigorous vision of the very definition of self through art and art through self.

Bruce W. Ferguson
Phoenix, Arizona

―――――――――――――

Bruce W. Ferguson is a cultural theorist who works both in academic institutions and more broadly initiates cultural interventions. He is currently the Director of F.A.R. (Future Arts Research), Phoenix, Arizona.

Colour Plates

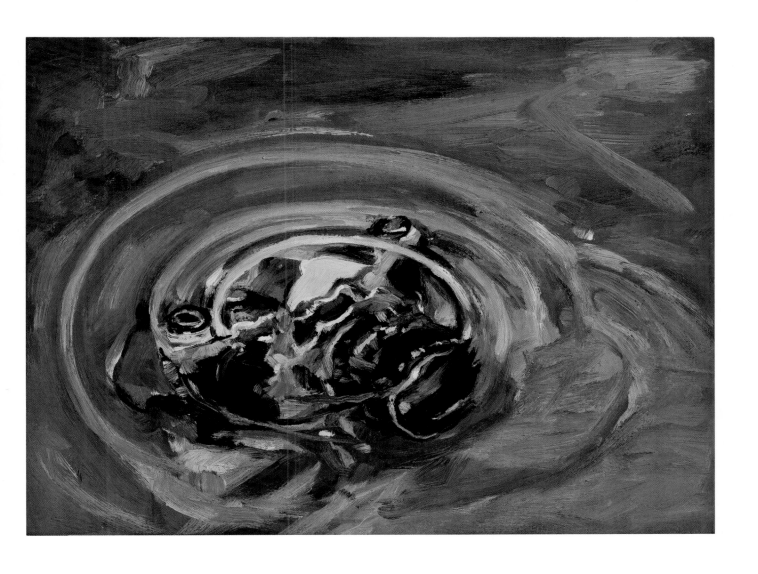

PLATE 1 *As It Is*, 1991 (oil on canvas)

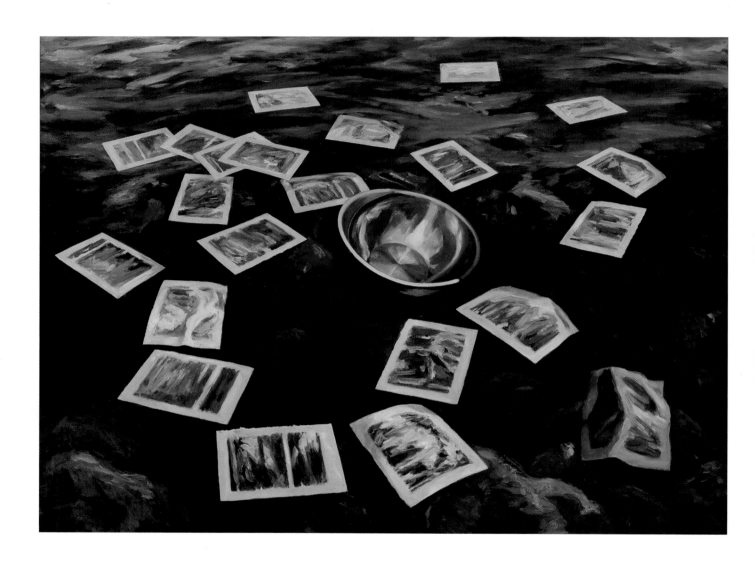

PLATE 2 *Literatus with Vessel*, 1989 (oil on canvas)

28

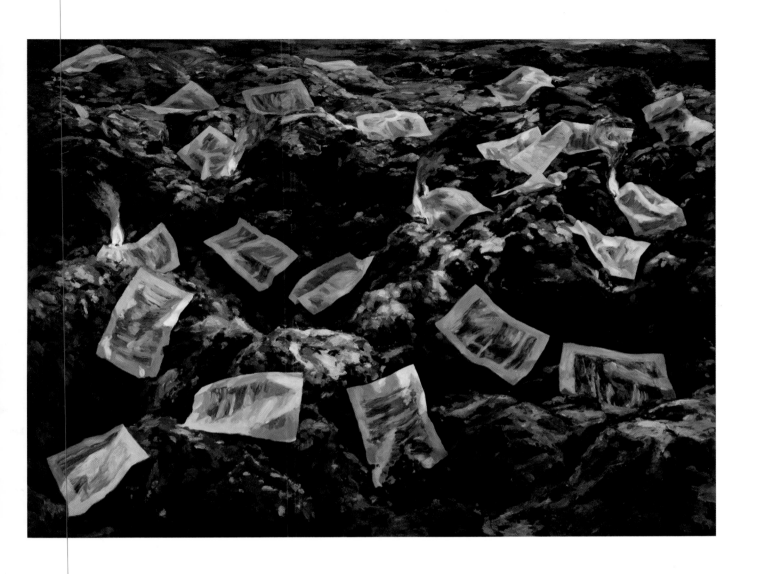

PLATE 3 *Literatus with Flames*, 1989 (oil on canvas)

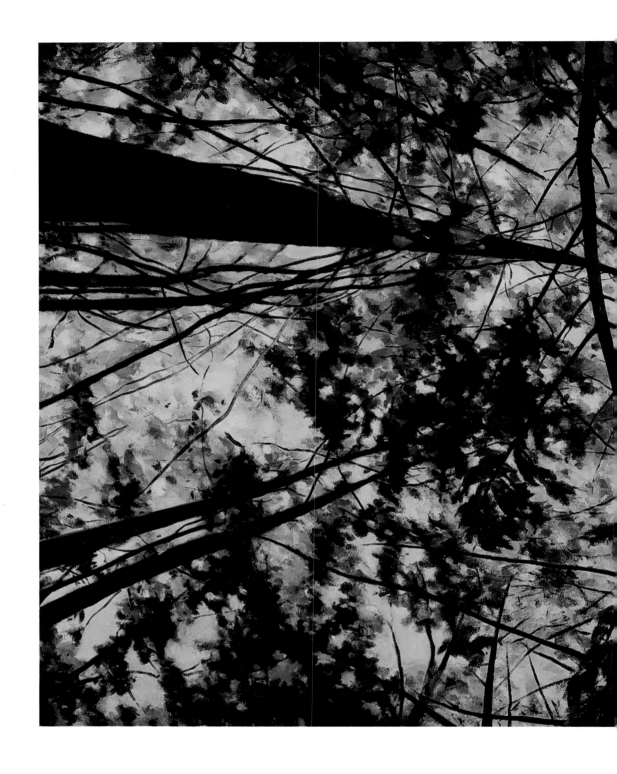

PLATE 4 *Axis Mundi*, 1995 (oil on canvas)

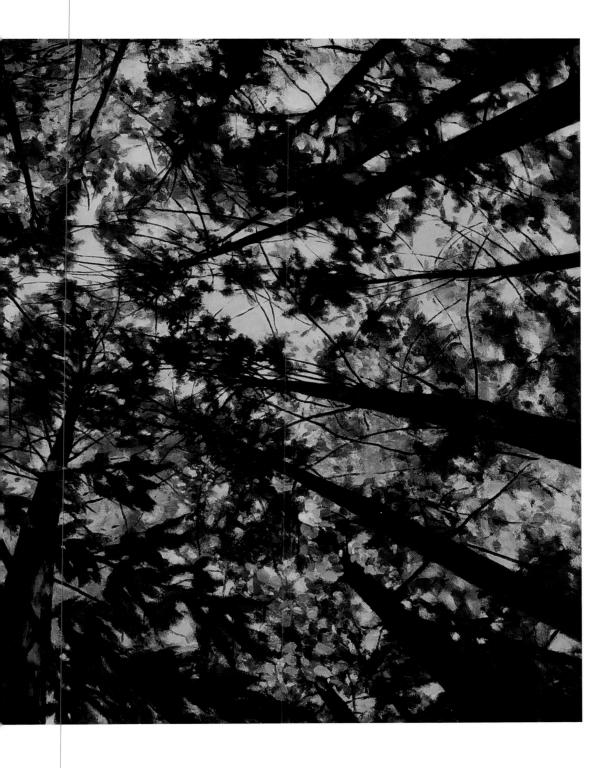

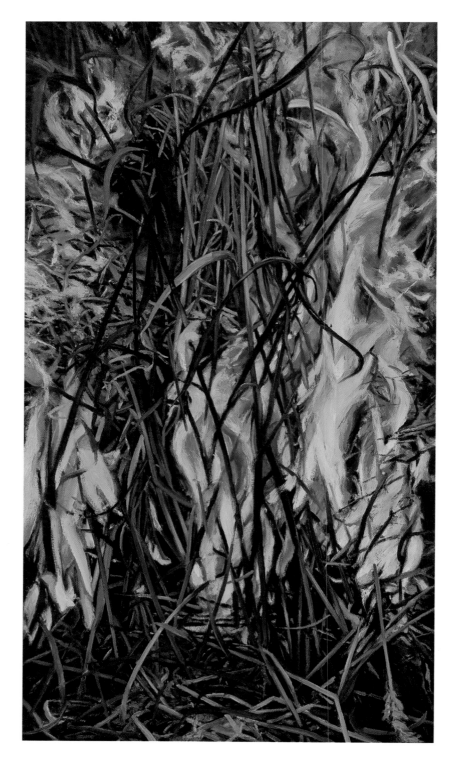

PLATE 5 *Grassfire (Fifth Burning Grass)*, 1993 (oil on canvas)

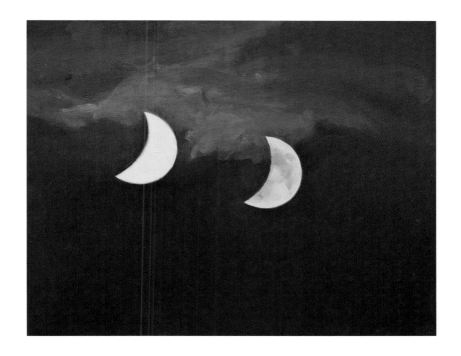

PLATE 6 *Double Negative: Two Densities*, 1997 (oil on canvas)

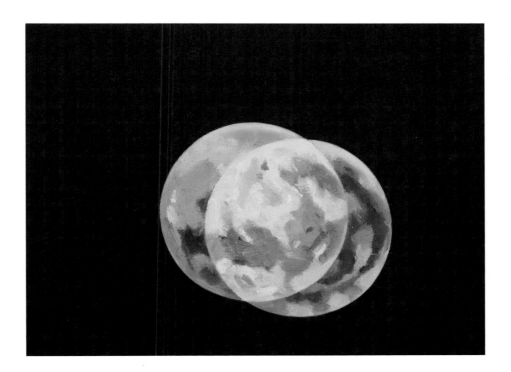

PLATE 7 *Double Negative: Transparency*, 1997 (oil on canvas)

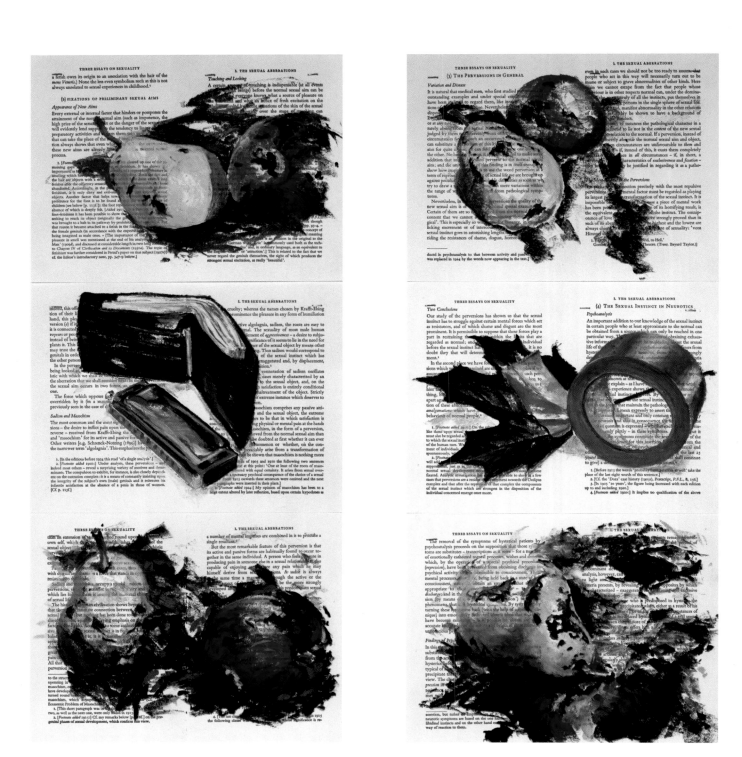

PLATE 8 (continued over) *Three Essays on the Theory of Sexuality*, 1989 (oil pastel and text on paper, detail)

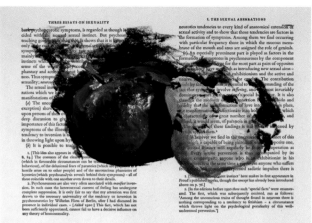
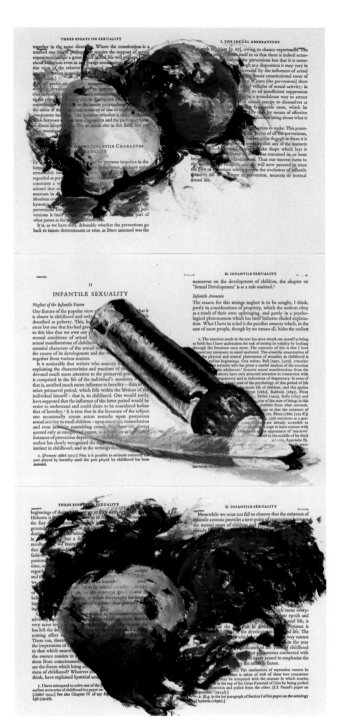
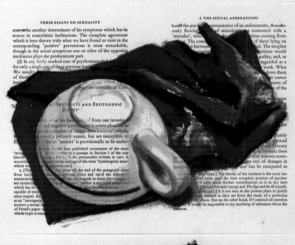
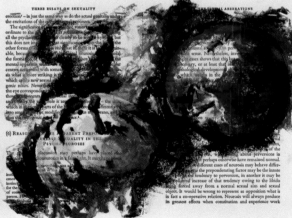

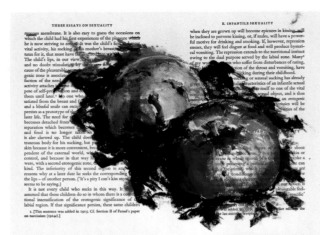

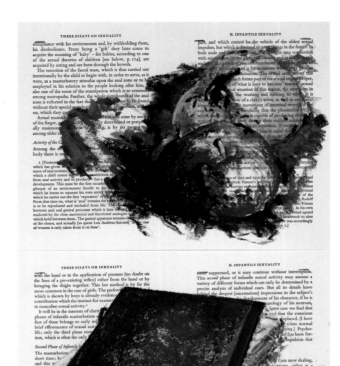

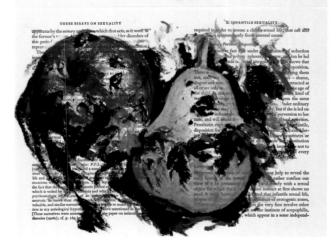

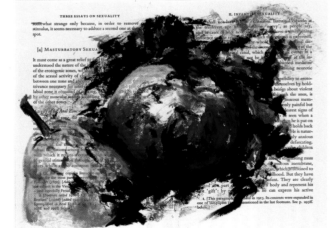

36

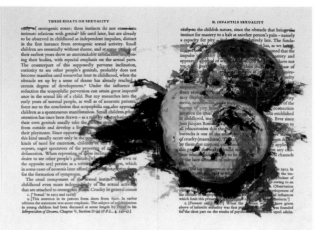

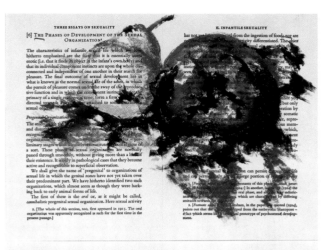

[6] THE PHASES OF DEVELOPMENT OF THE SEXUAL ORGANIZATION[1]

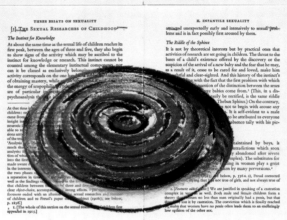

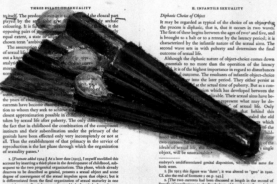

[5] THE SEXUAL RESEARCHES OF CHILDHOOD[1]

The Instinct for Knowledge

The Riddle of the Sphinx

Diphasic Choice of Object

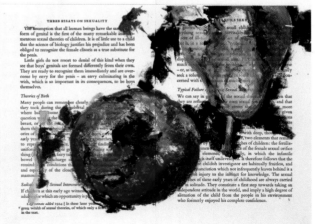

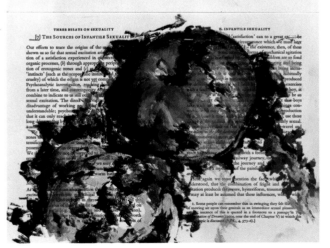

[7] THE SOURCES OF INFANTILE SEXUALITY

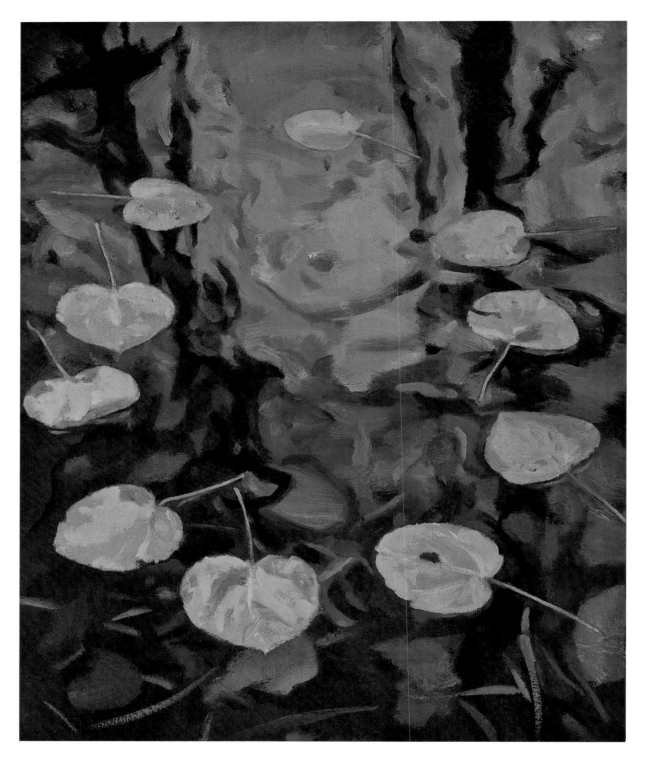

PLATE 9 (continued over) *Numerals*, 2008 (oil on canvas)

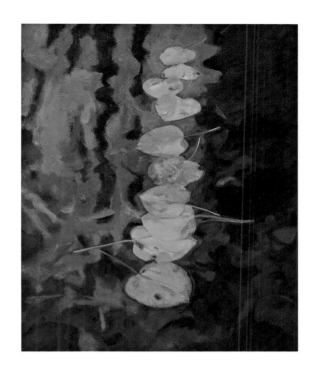

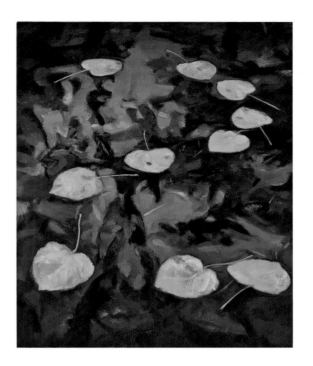

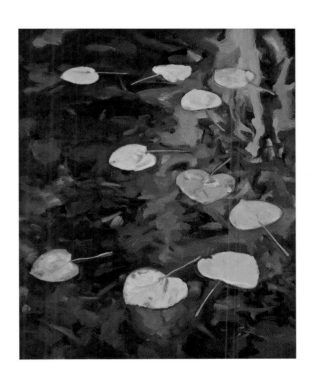

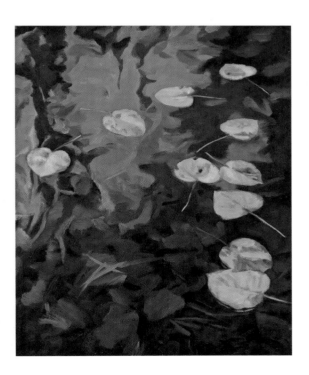

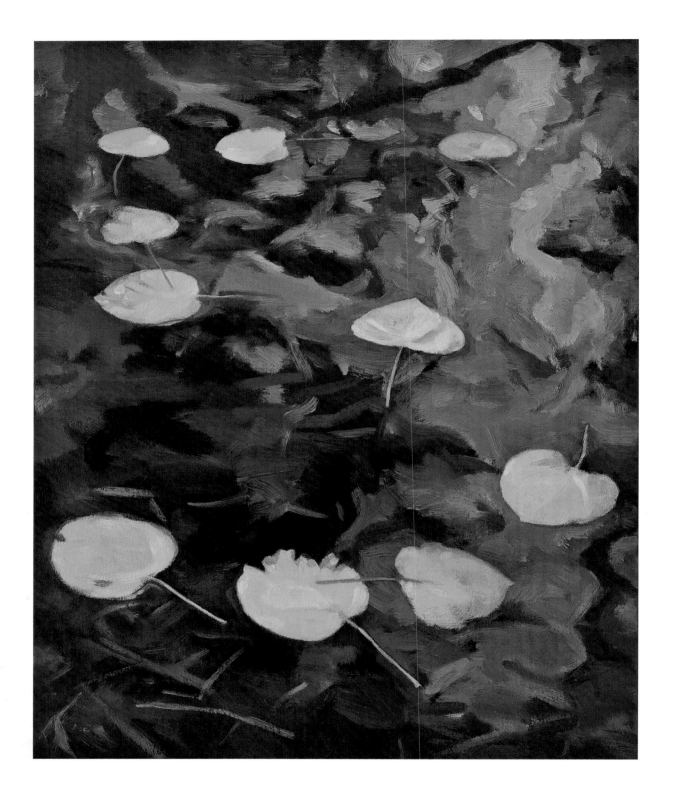

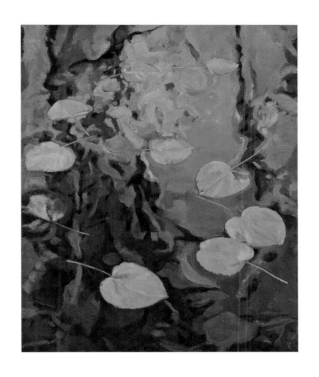
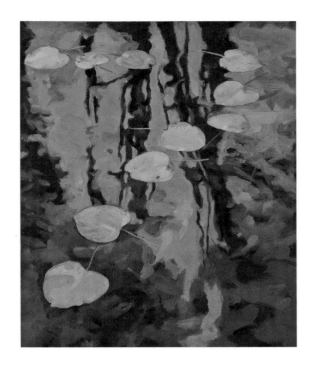
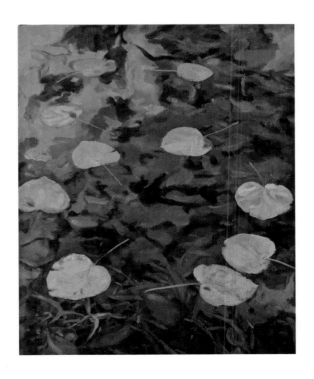
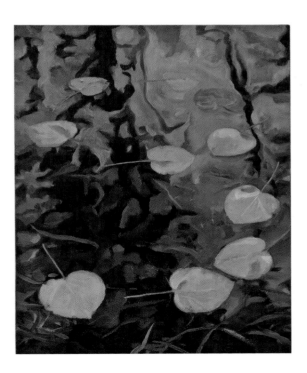

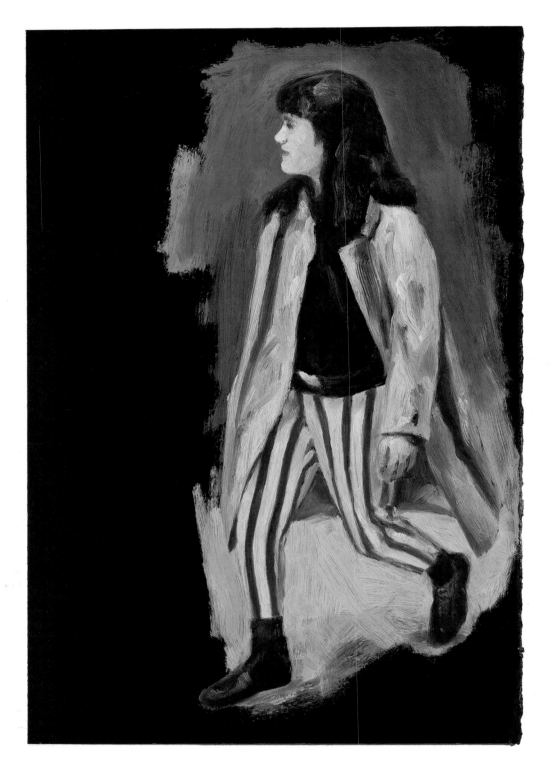

PLATE 10 (continued over) *Not Everyone*, 1991 (oil on steel)

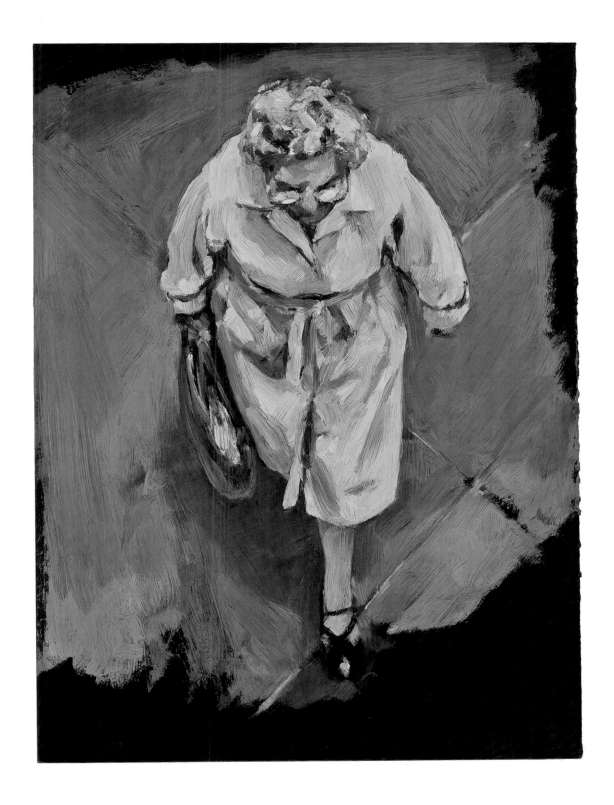

43

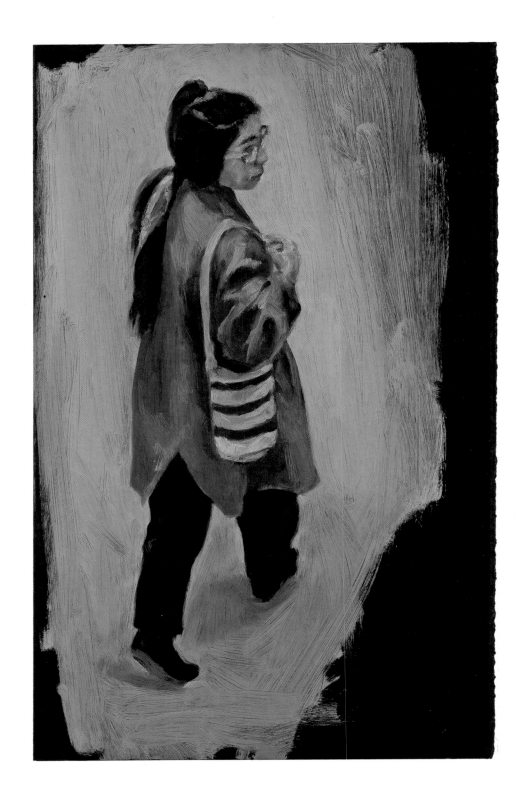

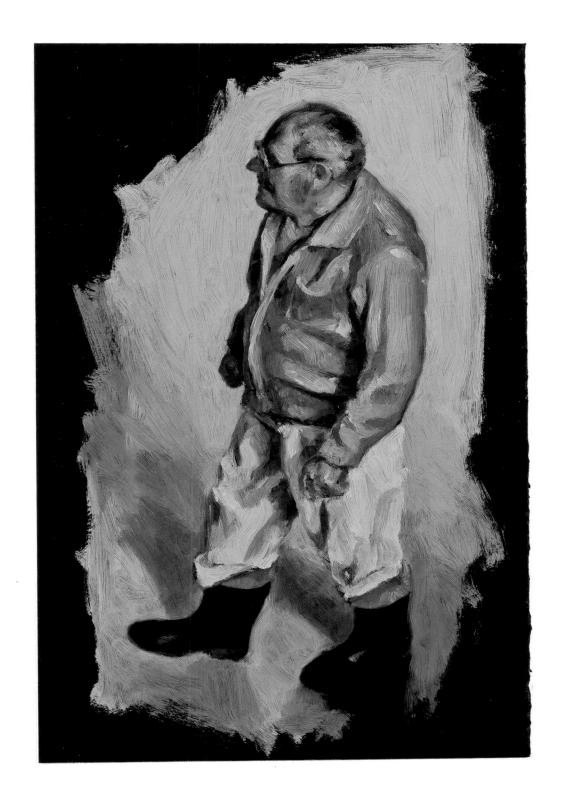

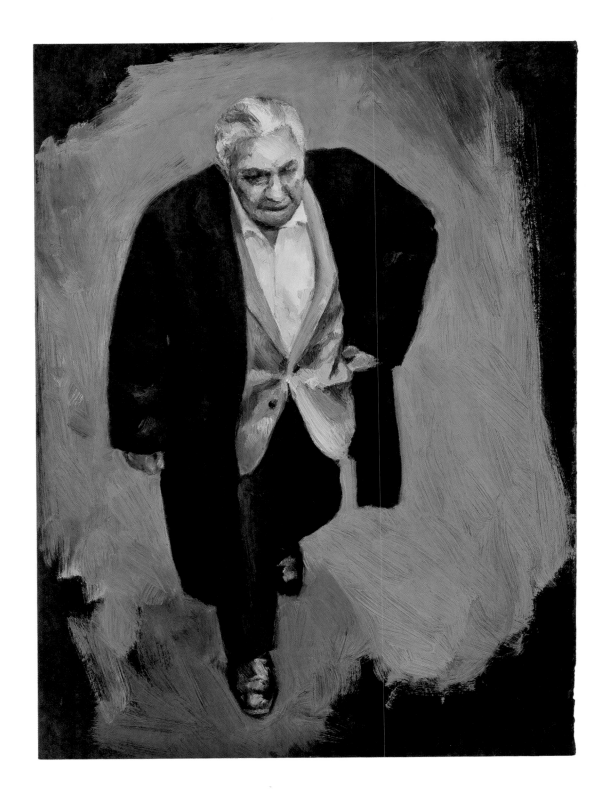

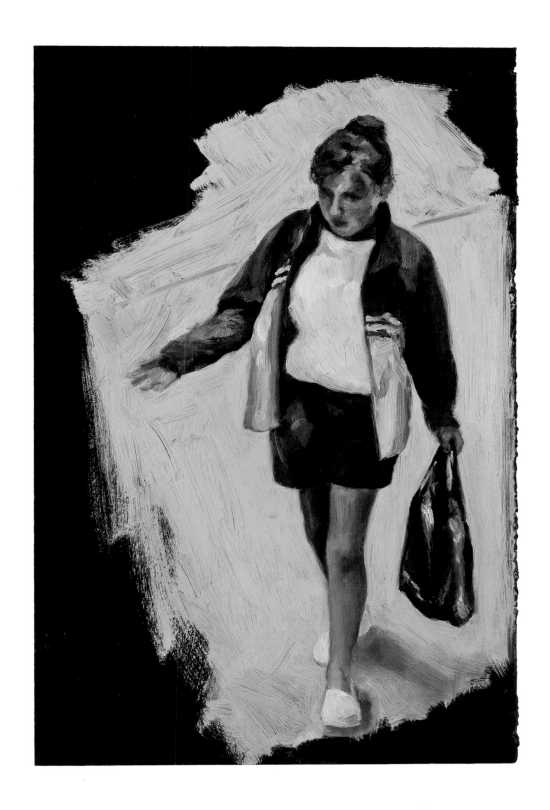

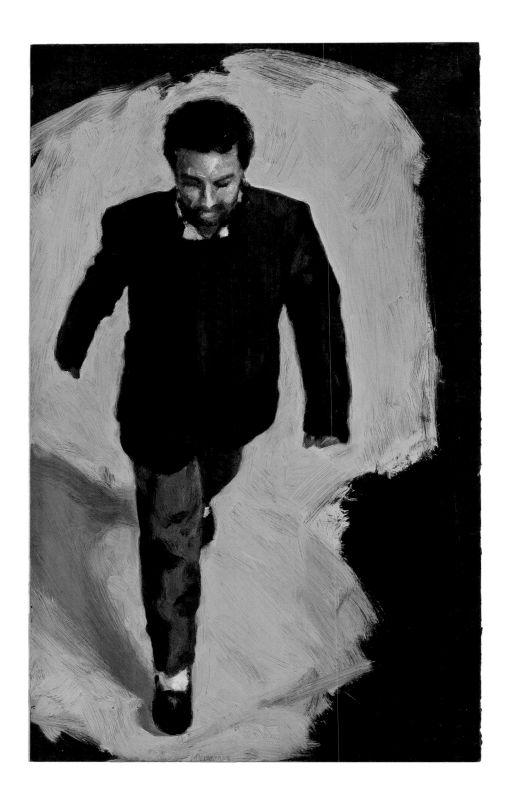

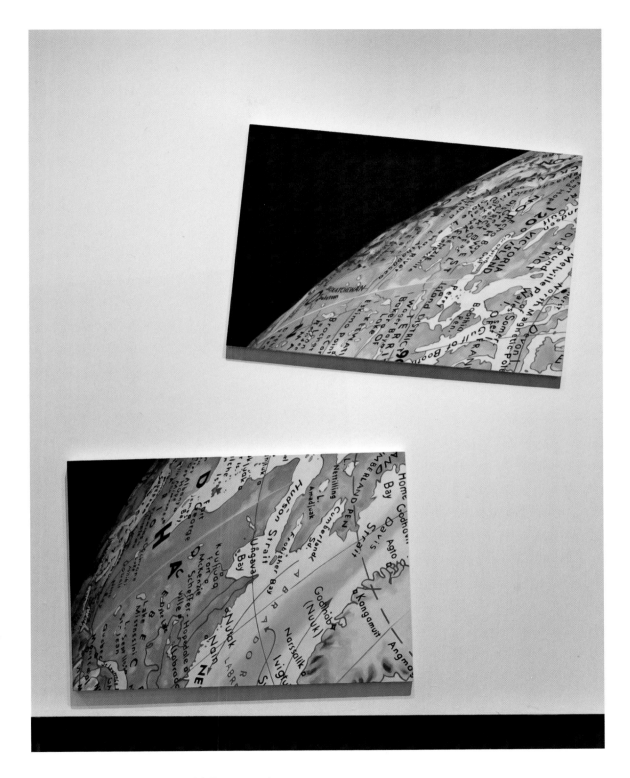

PLATE 11 *Peripherum View III*, 1996 (oil on canvas)

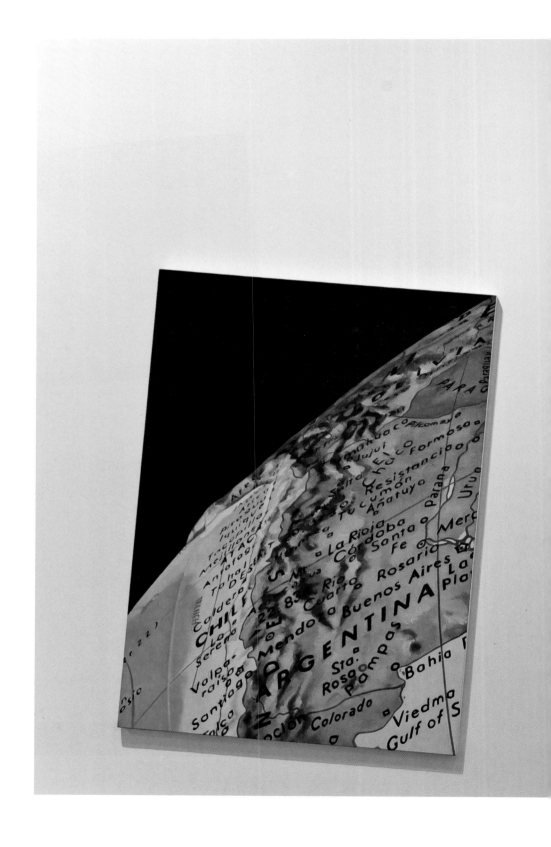

PLATE 12 *Peripherum View I*, 1996
(oil on canvas)

50

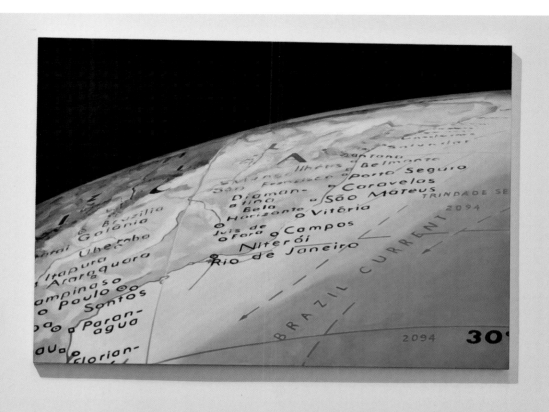

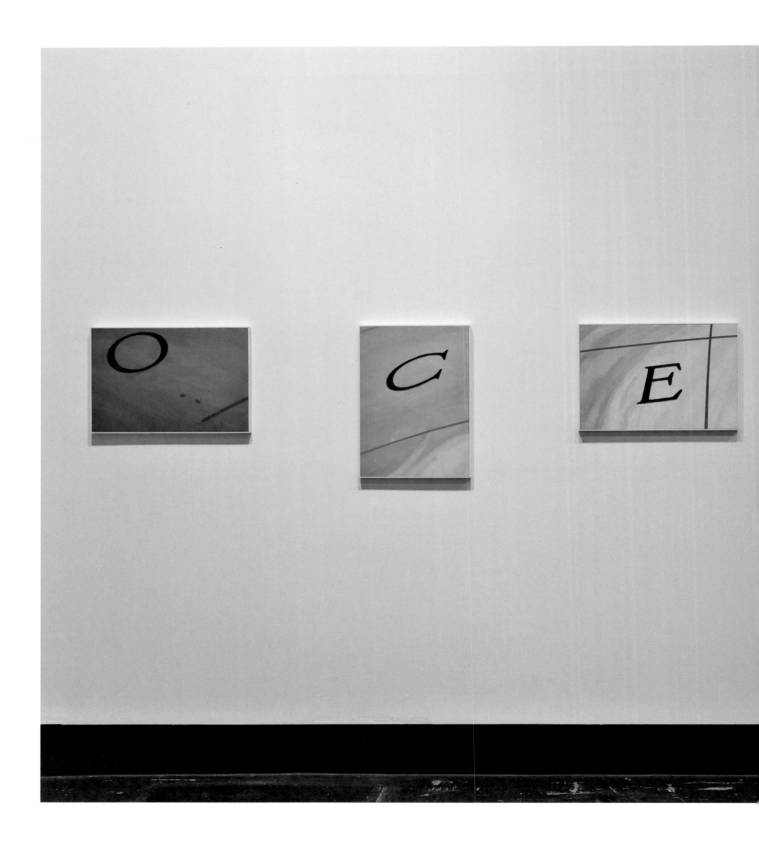

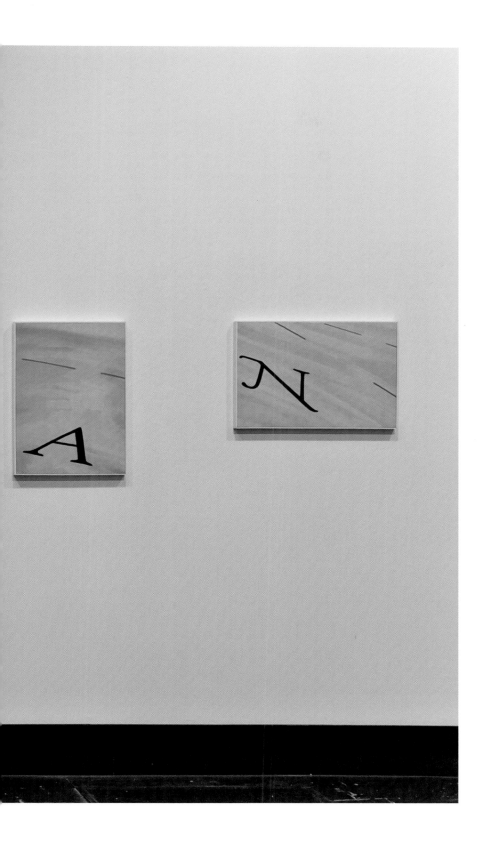

PLATE 13 *Five Oceans,* 1996 (oil on canvas, installation view)

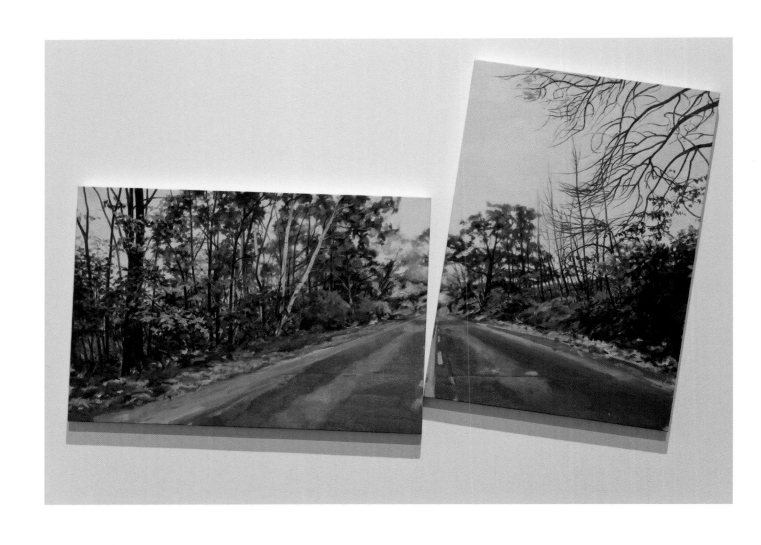

PLATE 14 *Road Near Glenora (Autumn)*, 1997 (oil on canvas)

54

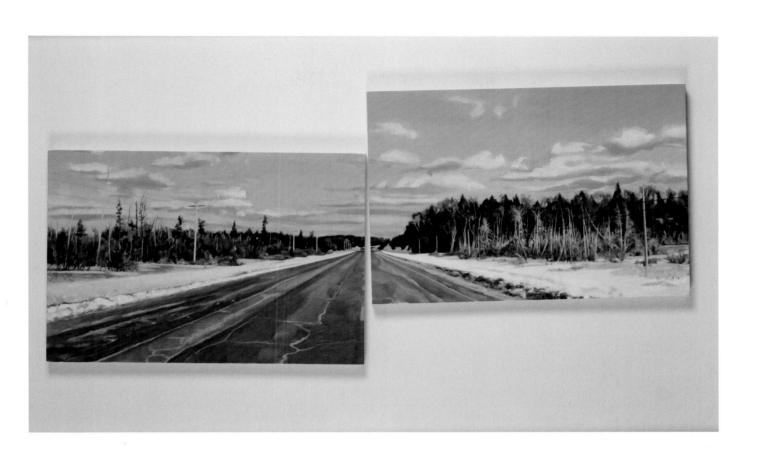

PLATE 15 *Road Near Madoc*, 1998 (oil on canvas)

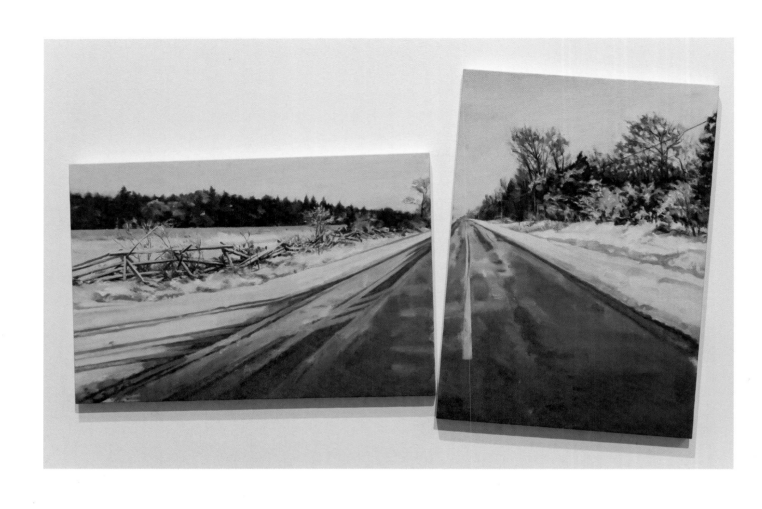

PLATE 16 *Road Near Carrying Place,* 1998 (oil on canvas)

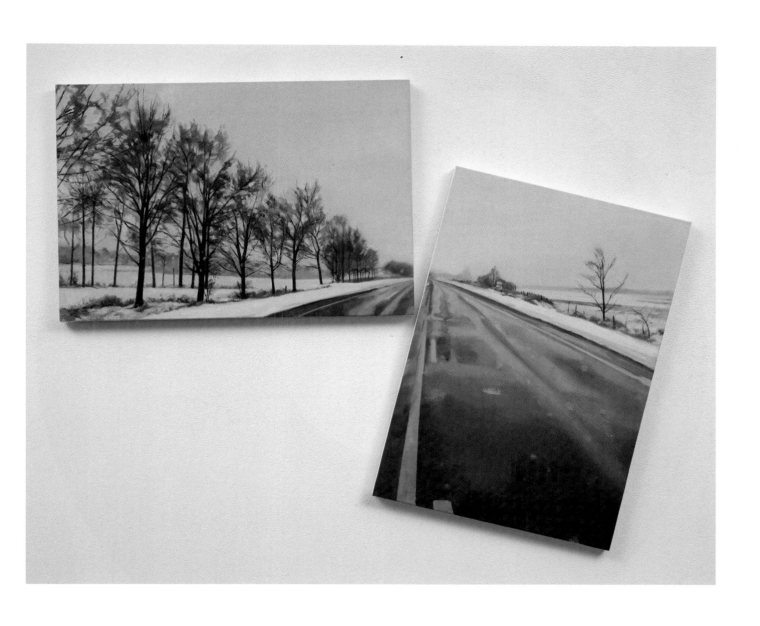

PLATE 17 *Road Near Wellington*, 1999 (oil on canvas)

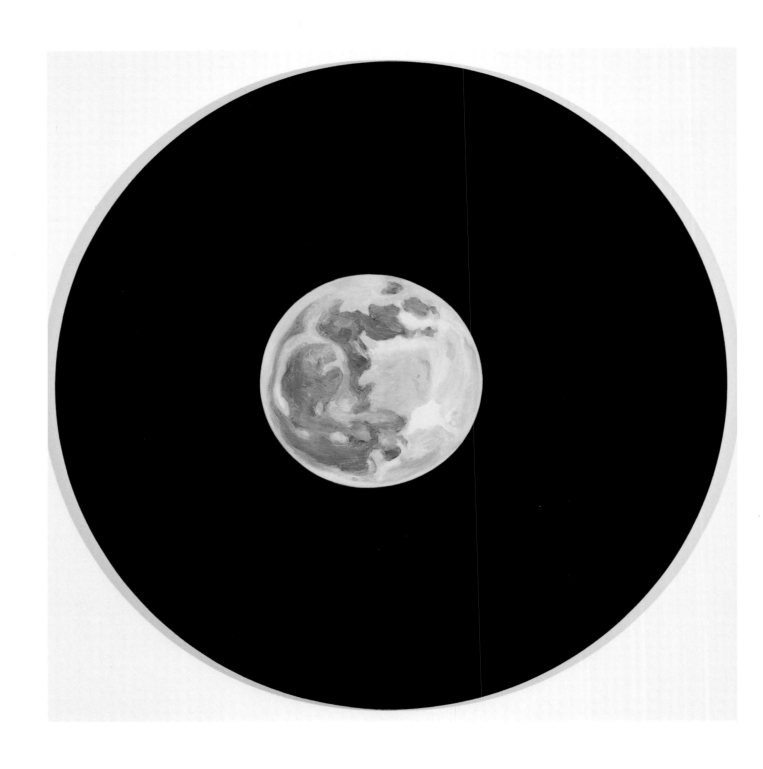

PLATE 18 *Moon Centre*, 2002 (oil on canvas)

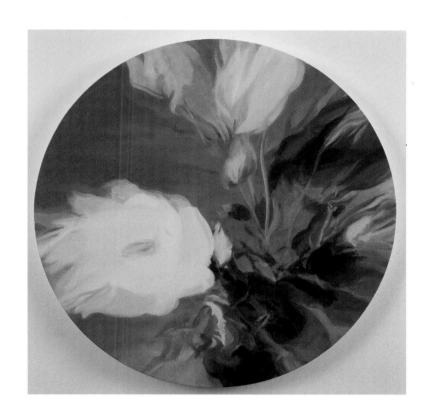

PLATE 19 *March*, 2002 (oil on canvas)

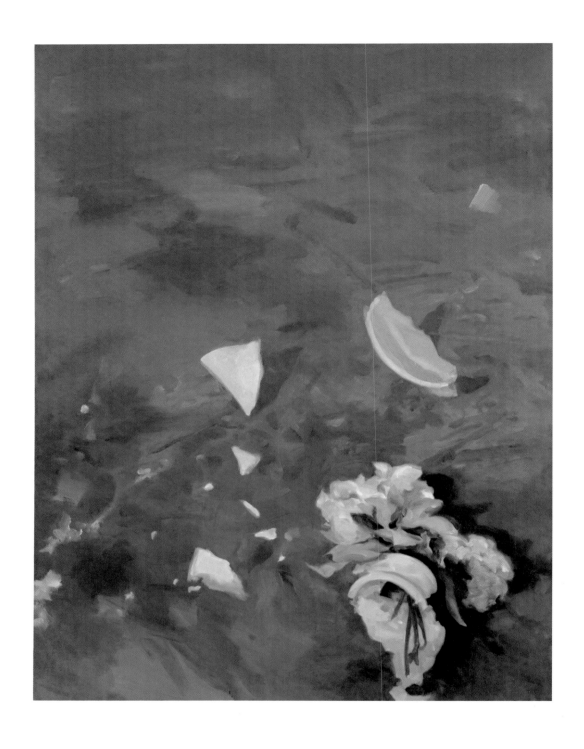

PLATE 20 *Pink Peony/White Vase*, 2005 (oil on canvas)

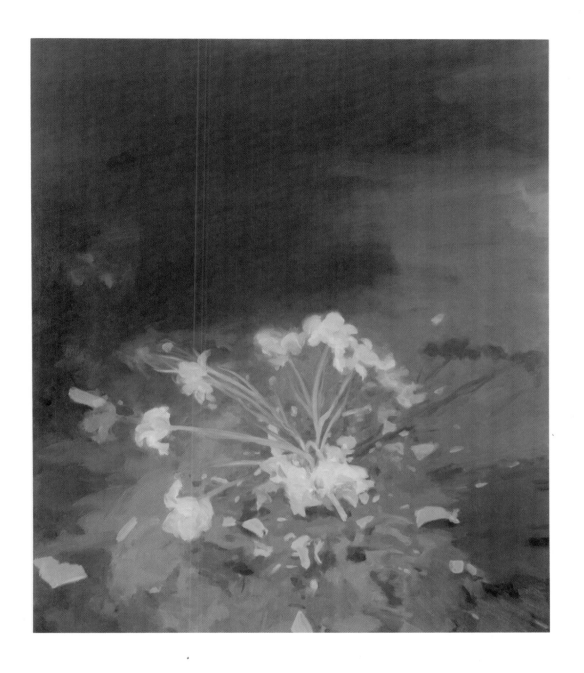

PLATE 21 *White Irises / Yellow Vase*, 2005 (oil on canvas)

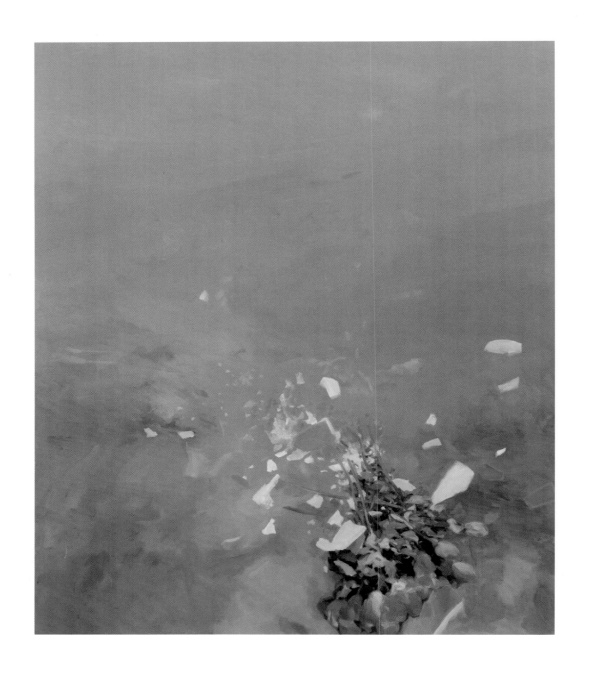

PLATE 22 *Red Roses / Blue Vase*, 2005 (oil on canvas)

PEGGY GALE

Will Gorlitz: Haptics

THE MATERIAL WORLD OFFERED UP SO RICHLY IN WILL GORLITZ'S paintings bespeaks deep memory and a celebration of nature and fruits of the earth. We enter into his paintings as if bodily to apprehend the features and landscapes presented there, the colour, the volumes, the textures: haptic reassurance, confirmed.

The paintings are strong and sensual, yet with an intelligence—an intellectual tension—that supports their physicality with a firm armature of decision making. There is *knowledge* here, both of the familiar world being depicted and of a just-glimpsed intuitive realm with further, subtle implications. All of the sites and situations—single trees, the forest canopy, grass fires or a country road, simple objects immersed in water, printed texts, fruits or flowers and leaves—have the quiet glow of intimate experience. There is an uncanny sense of *being there* evoked by memory and the physical image before us. When people are depicted, other sets of issues are broached in turn.

Gorlitz points out[1] that many of the motifs in his work come from his childhood experience in Winnipeg and that he has invariably used common or local material as the subject matter of his paintings. When choosing fruit he opts for apples and pears, not pineapples or avocados. For trees, it will be the flickering yellow aspens of western Canada or the tall conifers and deciduous clumps of southern Ontario. Even images of Earth and the moon are homely: the latter seen readily from his studio window as it

traces the sky, or the former taken from a globe or an atlas for his *Five Oceans* paintings, each ocean bearing one of the letters of its title.

This information is less simple than it may seem. Though his lived experience is Canadian, Gorlitz was born in Buenos Aires and came to Canada at the age of six, when he immediately started school. The family has a complicated history. His paternal grandfather was German and lived in South Africa in the early years of the twentieth century. Upon receiving an inheritance, he decided to relocate to Argentina, but during the ocean crossing, with the hyperinflation of the German mark in 1923, he lost everything. He was obliged to land in Paraguay instead, where he established a plantation and raised a family. His son (Will's father) was in turn soon sent back to Germany for his schooling, not once seeing his own parents in the next eleven years. When he returned to South America he met and married a Mennonite woman and moved to Buenos Aires to start a family. Canada, being a preferred location with pacifist Mennonites, as it allowed exemption from military service, finally became the family destination.

So Will was raised as a Canadian and quickly lost his facility in Spanish. He spent three years at the University of Manitoba but differed with the authorities on a matter of principle and completed his degree at the Nova Scotia College of Art and Design in Halifax. The family home had shifted through four continents in just three generations, and one might sympathize with a cleaving to the familiar in Gorlitz's choice of subjects, a commitment to the real and actual, to lived experience on his own terms. Some of his extended family's internal frictions may lie hidden within the muscular draftsmanship and insistent layers of paint—usually painted wet on wet—that are characteristic of Gorlitz's mature work since the early 1980s. Similarly, an ongoing recourse to personal memory and seen evidence argue for Gorlitz's firm clarity of statement. He has chosen Canada as his continuing home, but a consciousness of options and the fragility of decisions taken must underlie to some measure his sense of stability and normal being-in-the-world.

There is a hint of violence in the painted record. Despite the shimmer of yellow aspen leaves floating on quiet water, the surrounding pools are deep and blue-black, mysterious. Though he has portrayed many flowers over the years, blowsy peonies or red roses and cool, white irises, there are also the smashed vases of 2005, crash, crash, crash, perfectly depicted at the moment of contact and destruction. There are the cameras submerged in water, their evidence drowned (*As It Is*, 1991). *Not Everyone*, from the same year, shows a string of passing pedestrians as viewed from an upper floor, and was first installed in Kingston, Ontario, famous in Canada for its huge prison population and grey stone walls. Surveillance of some sort is clearly at issue here, and the painter's eye is shrewdly calculating. One considers, "Why *not* everyone? Who is left out?" and thinks involuntarily of other choices and different

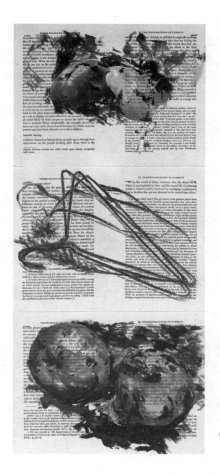
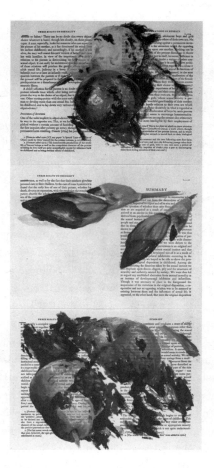
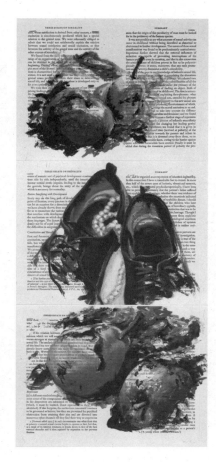

considerations. Even the decision to use the printed pages of Sigmund Freud's *Three Essays on the Theory of Sexuality* (1989–1990) as ground for an extended series of drawings in oil pastel—21 panels for the English version, 26 for French, and 17 for German—is subtly shocking.[2] Freud's positing of sexuality as central to psychology and the formation of mental life inevitably is implied in all of Gorlitz's choices for material depicted in the drawings and certainly colours the implications of the ripe fruit in its earthy surround interspersed with other articles from daily life: a broken globe, books with split spines, the leather wallet, a flashlight, or spent, smoking matches. The viewer is vividly aware of this evidence of painted reality but also— simultaneously—of his or her own weighted physical presence, acknowledging the experience of both bodily sensation and intellectual consciousness. Those apples and pears in their rich black earth fairly yearn to be grasped, even as one's eyes linger on a strand of pearls coiled in a man's pair of black shoes.

Will Gorlitz has a restless imagination, an insistence on production. He travels far, if only as an internal voyage, to the five oceans and to other parts of the globe.

Three Essays on the Theory of Sexuality
(details)

Will Gorlitz: Haptics

Closer locales are made strange by their wilful framing, as are many of Gorlitz's subjects over the years. These decisions are conscious ones, a determination to focus attention on the image seen split: two adjacent canvases aslant and linked by the even, broken horizon. The divided views offer a whole made of parts, implying all the other parts not included in the immediate view; strategically, they acknowledge and assume the viewer's willingness to complete the picture.

The painter's point of view is neither random nor a passively accepted norm. His wonderful treetops, in *Axis Mundi*, align our view straight up to the heavens. The trees gaze benignly down on us as we become another centre to their inverted view. We feel ourselves to be lying flat, but exalted we float upwards, still feeling the firm earth beneath our backs. In the *Axis Mundi* of 1995, currently in the artist's collection, Gorlitz returns to a theme he explored in a series of similar paintings produced a decade earlier. The 1995 work reflects his custom of reviewing older works with an eye to their further possibilities. The earlier series placed unusual additions between viewer and arboreal summit: a hovering wreath of branches and leaves, or large birds with folded wings, a slatted wooden box, a single sheet of rumpled newspaper, or an oversized silvery full moon high in the blue sky. The series as shown at Sable-Castelli Gallery (Toronto) in 1986 was subtitled *Centre of the World*; placed among the tall or broad paintings of soaring trees were smaller paintings of single individuals with eyes cast down to the earth, underlining their reversal of attention from the view skyward. One is caught between sites, hyperconscious of the gaze up, the gaze down, while recognizing the fact after all that each painting is placed normally on the walls, demanding our direct attention at eye level. The viewer remains poised for flight, grounded but unstable. Indeed the paintings of the trees in the exhibition each had titles—*Sleep of Reason, Playing the Part, Blind Spot*—while those of single persons, eyes downcast, were the ones called *Axis Mundi*, as if the position of central revolution is that of the Earth itself, while the soaring trunks and leafy branches had another, less certain, role to play.

Ten years later, Gorlitz returns to the image of trees rising to a zenith, as if seen from a prone position, but this time nothing intervenes in mid-ascent. A wayward branch cuts firmly across the middle ground, stabilizing the image, and the mysterious floating elements of the earlier series are abandoned. Now, a perfectly reasonable tree branch reaffirms our view, welcoming the exhilaration of the glance as it moves heavenward, while maintaining the normalcy of a firm wall holding the work level in our sights. Modernism's vaunted primacy of flatness for the picture plane is pointedly refused in these dramatic views and subjects. Gorlitz selects his subjects intuitively from elements in his immediate environment then considers them from many possible angles, moving logically from his original insight into an extended series or set of variations. A turn of phrase will generate an entire

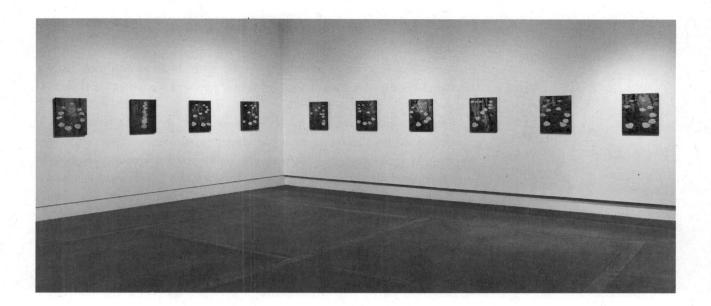

Numerals (installation view)

exhibition, installed to amplify and comment upon the theme and its implications. *Axis Mundi* is a fruitful notion, both point of centre and of revolution and resolve, an ideal panopticon.

Similarly, other series have been revived and extended, like the *Numerals* (1995) tracing out the decimal digits zero to nine in electric-yellow aspen leaves floating on blue-black water. The earlier group was sold separately and dispersed; the new paintings, of uniform size and shape, will remain together as a set. Similar images of aspen leaves on water were shown at Birch Libralato (Toronto) in 2005, the leaves in random patterns but the canvases of irregular shapes and varying dimensions; the leaves were freed to wander—wilfully, as it were—drifting quietly over their supports. For Will Gorlitz, working in series is an additive process, unhierarchical and open-ended, one thing leading to another. The irregular canvases seem a variant on the "expanded painting" of his earlier installations, which assembled non-painting elements (photographs, sculptural elements, or texts) to suggest broader readings of the material in the paintings themselves. An installation with multiple components *occupies space* more fully than a group of single paintings might do and permits an implied narrative to emerge from the arrangement of elements. The *Die Laughing* works of 1985 are one example, as is *Real Time*, produced for the Power Plant (Toronto) in 1994, with six digital counters and sixty open cardboard boxes laid out before paintings of roaring grass fires, urgent with pending disaster. Despite the artist's willingness to break up an installation when selling the works, the exhibitions themselves function as hypothesis or proposal, like a diary entry made briefly public, or a private musing—on time and history or light and darkness, recalling personal circumstances or events—known only to the painter himself.

This is beauty, but it is not sentimental: honourable rather than fond, lovingly insistent rather than merely natural, attractive, comfortable. The image is exciting but not simple.

Gorlitz has a special ability for "seeing bright," returning readily to images of incandescence, fire and the sun, luminous skies, and other sources of light. Similarly he seems fascinated with fluid surfaces, light glinting off water, or the dull sheen of metals. Repetition and comparison are constantly in play, as if making an affirmation after a moment of doubt or hesitation. Gorlitz's sheer ability to handle and manipulate paint, to call up physical sensations and tactile values through oil pigment on a canvas surface, bespeak his mastery of the medium. Consciousness of colour and its values, even its "gender" or personality, underlie his evocation of the conditions for sight and touch as primary means or forms of perception. He works quickly, even obsessively, translating a photographic "sketch" into the precisions and generalities of a painting in oils. The photograph is his model that is then abandoned when the painting reaches its moment of clarity, when elements from the imagination replace or elaborate a starting point offered by the photographic print now deemed inadequate. Basic or reduced forms are made more complex, more "interesting" or true; the photographs offer a ground-zero armature of real-world evidence, but this index is abandoned in favour of "art." Personal choices come to the fore at that point, based on the artist's experience of the world and his desire or knowledge of that world, that forming intention and visual result evolving in the painting before him.

There is a sense of repressed anxiety at play in this urgency to move forward, to populate the world with images from his mind and experience. Perhaps this sensation of contained energy and pending growth, radiance, reflects something of McLuhan's definition of "cool"—where a medium is the more engaging to the viewer precisely as it withholds information. Captured, the viewer seeks to complete the picture with his own responses, both visual and metaphorical, so that reduced, obvious, simple forms are made more complete, more satisfying through the viewer's own investment in the perceptual exchange. The several images of an open road leading to an unknown horizon, or of black space surrounding a glowing moon or planet, suggest a multiplicity of possible futures, while apples and pears comfortable in the mud affirm an earthy presence and pleasure in the everyday. Both mystery and the familiar are offered in Gorlitz's works, an ambivalence that is fruitful in its lack of resolution. Once again we are invited to gaze up, gaze down.

ONE RECALLS THE WRITINGS of Saint Augustine on the nature of memory: [3]

> And I come to the fields and spacious palaces of my memory, where are the treasures of innumerable images, brought into it from things of all sorts perceived by the senses.

Behold in the plains, and caves, and caverns of my memory, innumerable and innumerably full of innumerable kinds of things, either through images, as all bodies; or by actual presence, as the arts; of by certain notions or impressions, as the affectations of the mind, which, even when the mind doth not feel, the memory retaineth, while yet whatsoever is in the memory is also in the mind—over all these do I run, I fly; I dive on this side and on that, as far as I can, and there is no end. So great is the force of memory, so great the force of life, even in the mortal life of man.

And so the general experience of the senses, as was said, is called The *lust of the eyes,* because the office of seeing, wherein the eyes hold the prerogative, the other senses by the way of similitude take to themselves when they make search after any knowledge.

The eye is primary to all perception, and *lust of the eyes* suggests the eagerness of its apprehension and its role in affirming memory. The eye touches as it gazes, incorporating the image as experienced.

THE EARLY PAINTINGS OF Will Gorlitz were generally post-formalist, a conscious rejection of Pop art and what he perceived as the deep cynicism of Andy Warhol. Édouard Manet and Francisco Goya were historical inspirations. Through growing familiarity with the work of Gerhard Richter, Daniel Buren, and Richard Tuttle, and an appreciation of Canadian artists Paterson Ewen, Michael Snow, and Shirley Wiitasalo, he found that painting could, for him, "reinvest that internal notion of the world that other forms edit out, by necessity," and that "The image [of the world] we hold internally is *reinvested* during its making."4 Paint could capture eloquent light, extreme contrasts and detail. The visible world was challenged to reveal itself, as Gorlitz sought to discover how the image is formed and decoded by the human eye. Photography, too, was scrutinized for its translation of fleeting movement to blurs and mental re-figurings. Gorlitz was never interested in the imaginative limits implied by photorealism. He questioned paint itself, and decided that while black paint yielded a sense of darkness through *absence of light*, white paint indicated *paint* alone, without metaphorical implication. For Gorlitz, perception is both visual and physical: image and touch. The technology of handling and representation—form, structure, medium, texture—is always at issue.

What, then, to represent? The world of the senses presents itself everywhere, but moral choices require consideration. Gorlitz hesitates to applaud "progress" as desirable or even possible, since at best it leads to an apocalyptic division of the saved and the damned. To that end he eschews single "master" works, opting rather for seriality—not as "progress" but as a *series of tries*, revisions, and corrections—to

explore the implications of a given work or subject. He identifies and explores problems and discovers and investigates new paths suggested by earlier works. Nothing is presumed to be definitively finished; all work remains open for reconsideration and further sequencing. Changes in colour or scale may result, or formal modifications suggested by geometry: the bisecting of an image, or its rotation through a frame. Some of these processes are pragmatic: a means to review and understand more fully. Classifications open: ontology offers a consideration of the philosophical theory of reality and the universal and necessary characteristics of existence itself.

Will Gorlitz is mapping an external world while he pursues his own subjectivity and his experience of the sublime, a physical and intellectual being-in-the-world. The works are propositions, their meaning conditional and relative to their context. They are unfixed, retaining a status as *potential*, and responsive to changing times and different audiences—open to review and further development, new thoughts.

Never simple, even in their simplicity, these paintings demand engagement, insist that viewer and viewed, signifier and signified, mind and body, artist and audience, all meet together at a threshold of meaning. *Gloria mundi.*

Peggy Gale
Toronto, Ontario

Notes

1 In conversation with the author, at his studio in Guelph, Ontario, 29 February 2008.
2 This series is discussed elsewhere in some detail. See Jerry McGrath, "At Home with Freud," in *Will Gorlitz: Three Essays on the Theory of Sexuality* (Vancouver: Artspeak Gallery, 1989), and Caroline Bell Farrell, *Will Gorlitz: The Three Essays Trilogy* (Oakville, ON: Oakville Galleries, 1990).
3 *The Confessions of St. Augustine,* trans. Edward B. Pusey. The Harvard Classics, Vol. 7 (New York: P.F. Collier & Son, 1909), 173, 181–82, 197.
4 Will Gorlitz in conversation, 29 February 2008.

Peggy Gale is an independent curator, critical writer, and editor who specializes in contemporary art. She is based in Toronto and was awarded the Governor General's Award in Visual and Media Arts in 2006.

JEFFREY SPALDING

Heart, HEAD, Hand: Adrift on a sea of words

AN AIRPLANE THE SIZE OF THE EASTERN SEABOARD TRACKS ITS way across Canada. In its cabin, screens register its position and measure its progress, alternating between the mapped route and thoughtfully provided data: air speed, altitude, distance to destination, wind speed, temperature outside the plane, local time, and weather conditions at destination. If I choose, I can peer out the window through the clouds to decipher 30,000 feet below us the outskirts of Winnipeg, the city in which Will Gorlitz was raised. Instead, many of my fellow passengers and I are transfixed by the flickering screens in the seats before us. In time we'll touch down at Halifax, the city where Gorlitz received his grounding—his undergraduate degree from the Nova Scotia College of Art and Design. I wonder what might have been if instead he had stayed on and finished the program he had begun at the University of Manitoba. His mature art embraces landscape and still-life, painted in pastel-toned and subdued earthy, neutral tones. Do these proclivities not seem connected to the story of Manitoba's School of Art? Aspects of his work, his quiet introspection and delicate touch, bear comparison with many of the signature house-style attributes of L.L. Fitzgerald, Joseph Plaskett, and Takao Tanabe. However, Gorlitz jumped ship, so I must too.

Gorlitz has traversed the country, has lived and worked in many places. His work too encompasses a wide expanse; he is an artist whose principal area of interest is hard to pin with precision. We can view his disparate projects and discern that he has

dealt with most genres of painting: landscapes, seascapes, moonscapes, portraits, self-portraits, still-life, nocturnes, and floral subjects. His approach toward each is so personal, idiosyncratic, inventive, and contemporary that we might not recognize that the work belongs to these historical categories. Where are we going? Where does all this lead? I return to Halifax, the base. Here I begin to trace the path Gorlitz took on the remarkable odyssey of twenty-plus years examined by this exhibition.

Nova Scotia College of Art and Design University has a well-deserved stellar reputation. More properly, it has two or more reputations. In its initial manifestation, as the Victoria School of Art, it championed the craft credo "Heart, Head, Hand." At that time, NSCAD acknowledged the desirability of balancing the various spheres of influence in the creation of fine art. Historical accounts record that by the early 1970s, as Will Gorlitz enters the *new* NSCAD, the college has tipped the scales in favour of a *new school of thought*.

At NSCAD, as a bastion of the emergent generation of conceptual artists, the mind held dominion. It was evident to all present that traditional object-making (anti-commodity, anti-object, contrary, ornery)—and painting in particular—was persona non grata. Embattled, under threat, the conventions of painting and its accumulated craft were held in suspicion, even in contempt. The new art demanded results that rebuffed the trappings of art's history and sought urgent renewal through steadfast denial of customary pleasures. Equally suspect were infatuation with the skills of the dexterous hand, with genius, and with flights of fancy into the poetic heart of mankind. The proof of the art was in its argument, not its execution. Here was a working-class revolt against self-indulgence and excess, rejecting solutions, themes, and subjects commonly associated with pleasure: beauty as bourgeois. To be avoided were all the seductions of history that drew one down the known path and thereby inhibited any exploration of unknown territory. What once was evidently right in the practice of art became obviously wrong, and with this came a commitment to accept reversals of earlier judgments and expectations as a key toward reinvigorating art.

At NSCAD, justification and rationalization were required to demonstrate that it was ethical to even consider making a new physical object at all, never mind one that retained even a closeted allegiance to the traditions and hierarchy associated with the established history of painting. Key faculty and high-powered visitors jousted for position within the pantheon. Graduate students were subjected to tests of loyalty, purity, and commitment to the task. For the new art, anything was possible—except for the customary, that is. Painters needed to take deliberate measures to avoid the charge of being labelled *bête comme un peintre*. Transgressors faced being judged disparagingly for their lack of intellectual prowess and treated with disdain for their moral lapses.

Revolutionary thought induces extraordinary results, and many of the wonderful works of the period flourished as a result of this purging. Revolutionary thought can

also occasion calamity; many artists failed to chart their course through these turbulent waters. If an artist were going to make a painting under these circumstances, he had better have in hand a pretty good cover story. Most simply fell silent.

Post-conceptual painting at NSCAD remained primarily dedicated to solutions that were linked to austere, reductive abstraction. The postures of rationalism generated work that attempted to maintain a balance between the appearance of the calculatedly casual and the serendipitously structured. By the mid-1970s this posture had become the established paradigm and thus subject to overhaul and outright revolt. Permitted to exist somewhat under the radar was a contingent of young painting faculty and visitors. New Image painters David True, Eric Fischl, and Tim Zuck were joined by the iconoclastic Gerhard Richter and Matt Mullican, among others. They tried to operate in a zone between conceptualism and modernism.

Their work supplanted the modernist-formalist doctrine of art for art's sake, aesthetics, and beauty. In its stead was posited a reflective examining spirit. Painting could turn its attention to any number of life issues and perform the role of social observer, political activist, personal redeemer, or psychological exorcist. Somehow, amid this intense trial by fire, the undergrads of NSCAD were the survivors and the best poised to absorb the lessons, yet moderate, recover, and move forward in a new direction. Notable among them were Landon Mackenzie, Doug Kirton, and Will Gorlitz.

Young NSCAD faculty were a generation whose own art training did not benefit from formal classes in traditional drawing. By the mid-1970s California conceptualist John Baldessari was sporting a rubber stamp on his visits to Halifax, liberally affixing on various and sundry surfaces the directive "Learn to Draw." The NSCAD faculty taught themselves to draw—after hours, surreptitiously, in the privacy of their own studios. Gorlitz and his compatriot students had access to some of the traditional means of artistic instruction. Drawing and painting classes were often based upon observation, perception, and development of mimetic skills of representation, even if delivered by faculty whose own development in this regard ran but a few short lessons ahead. Therein lay the perverseness of the NSCAD position. During this time of transition, figure drawing was mandatory for students while traditional representational art was reviled by the instructors.

Perhaps no one truly knew what was intended or condoned, yet this generation of undergrad students evolved to shape an art that was intelligent and mindful yet at its base representational and narrative. Over the course of development these artists attained a position that demonstrates that painting can cohabitate with the appearance of social activism. Gorlitz's evolution follows this path, refining, remixing, and rebalancing the prominent roles ascribed to each of the domains Heart, Head, and Hand.

Three Essays on the Theory of Sexuality

We can sense shifts in these priorities and allegiances both in the works selected for this current Gorlitz exhibition and in their presentation. He chooses unexpected alignments. Considering that Gorlitz privileges order and rationality, it may seem puzzling at first that this survey show groups works out of the chronological order of their creation. But this asserts the possibility of bringing continuity to a lifetime of searching, with recent works used to coax fresh discoveries of recurring themes from earlier ones. For my part, to make sense of it all I must travel a pedestrian route, from start to finish. Only then can I understand why certain works and themes are selected from his overall production for inclusion in this significant exhibit while others are left out. I sense a significant organic evolution in the work of Gorlitz, a progression that charts the increasingly important role of the effectiveness of the artist's hand and surrender to the dark province of the human heart.

The earliest project included in the exhibition, *Three Essays on the Theory of Sexuality*, establishes Gorlitz's modus operandi. He is restless in his commitment to find new grounds for painting: he has painted upon canvas, wood, metal, paper. His canvases are often shown askew, at atypical heights, or set directly on the ground. In *Three Essays on the Theory of Sexuality* his painterly gestures interact with graphic blocks of printed text. At its most basic, this intersection disrupts our expectation of a painted figure upon an untouched blank ground. Yet it is not neutral space that is displaced, it is the Freud section of the images—*Infantile Sexuality*, in English, French, and German. Gorlitz's imagery does not illustrate or explicate the text; our initial observation is that Gorlitz obstructs and disjoints engagement with the flow of Freud's linguistic thesis. The essay's argument structure is supplanted by a jumble of icons/symbols. Across the top and bottom lines are a series of still-life pairings of an apple and a pear. Sandwiched between is a row of man-made objects.

The overall coloration is stark, strident: red, yellow, ochre, and brown anchored by dominant black. As a scheme for the still-life panels, this recalls the palette and style associated with Carl Schaefer, Will Ogilvie, and the generation of prominent Canadian watercolour painters of the 1930s through the 1960s. An autumn drive past roadside fruit stands of rural Ontario lurks somewhere in the mix. In particular, these panels establish dialogue with the expressive flair of paintings of the 1950s by David Milne.

A topology of the still-life panels suggests that the works explore most of the compositional permutations of the pair of fruits they depict. It appears that relative to the pear, the apple remains fairly stationary, inclined in one orientation. Meanwhile, the pear tumbles all around the apple as central locus, always touching, abutting, and maintaining physical contact. More or less, left to right, the orbit occurs clockwise in the lower panels and counter-clockwise in the upper line. One final panel shows the two separated by a space.

I used to think that the fruits were portrayed in stages of decay. I realize now that this is inadequate. We can detect certain surface blemishes on the pear and apple; these seem simply to define the specific character of the participants, assuring us that the same two appear throughout the sequence. There is no significant increase in the number of bruises or black pocks or in the severity of the bruises from panel to panel. This would have taken us down the road in contemplation of life's cycle from birth to maturity to decay to death, in an interpretation that is at least as old as the Dutch still-life tradition (a genre that is rife with symbolic intention). Instead, the energetic black marks flare over and through the two fruits, more emblematic of motion and jostle than decline and rot. But our view of these arrangements cannot be ascribed primarily to any formal inquiry, on the part of the artist, into varieties of compositional arrangements of mark upon paper. Literally in the face of Freud, we have to engage this fruit dance as a sexual frolic, a courtship tussle on ruffled drapery.

Unlike the upper and lower lines, the central panels are painted non-expressionistically. The objects sit in isolation upon placid, unpainted backgrounds. The middle line of imagery dislodges any notion that its intention is largely aesthetic. Moreover, if we miss it on the surface, the title reminds us this work is more than a studio exercise with a nod toward the newspaper collages of Picasso, Braque, and Rauschenberg.

Resident along the central line of this seminal work are the seeds of a future flowering. Gorlitz visits themes that recur throughout his career—numerals, shattering elements, constellations, fire, desecrated texts, cranium globes, empty vessels, mirrors, pairs and couplings, spheres and tondi, orderliness and messiness, spirals and concentric circles, delicious decay and disorder. *Three Essays on the Theory of Sexuality* is the Gorlitz equivalent of Duchamp's *The Green Box*, his veritable Rosetta stone.

A book has been ravaged, tattered, torn from its binding, and piled back together askew. From the form and look of its cover, it could be a Bible or perhaps some romantic travelogue such as we relished in childhood. We are presented with the image of the bottom half of a desk globe, which introduces a counterpoint of blue into the overall schema. Its interior is a gleaming vessel waiting to be filled—with water? To quench thirst? Freud's phrases leap from the surrounding pages. He asserts that a child between the age of three and five gains an instinct for knowledge. Gorlitz presents the southern hemisphere of the globe, including South America and the Argentina of his birth. Are we to believe, then, that this work is a personal diary of Gorlitz's passage into awareness of carnal knowledge?

Invariably we are drawn back to the tantalizing phrases and intentions of the words still visible. We yearn to piece together the hidden Freud narrative: secrets concealed beneath a cloak of paint. Gorlitz engages us in a struggle to square the elements, the inferences of the phrases coupled with the visual symbols: the surrealist stratagem of provoking a clash of unexpected characters upon a common ground.

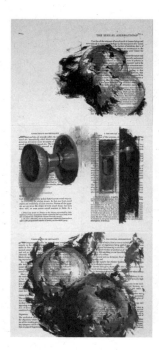 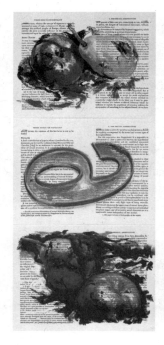 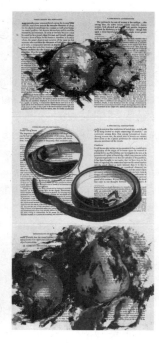 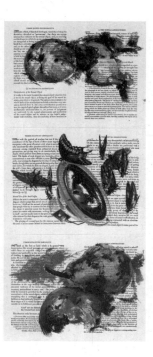

Three Essays on the Theory of Sexuality
(details)

Within the prescribed literary context of everyday objects, knobs and latch, apple and pear cannot help but play out phallic, sexual functions. A sideways 6 is set beside an image of a coiled belt parodying the number 9. A mirror reverses the 9 to a 6. Meanwhile, a glowing stovetop element, a domestic controlled burn, a coil, further evokes this numerical scheme. These images provide the perfect visual pun—or at least sophomoric humour—to overwrite a passage concerning infantile sexuality. Sexuality, desire, and the mysteries of the body are made palatable and graspable through attempts at explication via theories: emblems of passion.

Early in Gorlitz's career, this type of sleight of hand is perhaps used to distract from the slightness of hand and mastery of the painter's craft that will later fully develop. The primary impact of the project is little reliant upon our assessment of the ability of the painter to render lush fruit and recognizable objects. We are left to admire the work for its directness, for its raw desire to speak in urgent ways about a philosophical question. Gorlitz needs to understand his place on earth by appealing to intellect and reason. All the while he posits a battle with the nasty messiness of nature that insists upon breaking down, hurtling towards decay at speeds and at moments that defy our intervention.

Is the project a curious allusion to, and a wistful recollection of, the sacking and destruction of Freud's Vienna library—a sacking made all the more poignant for its having occurred at the hands of other intellectuals rather than schoolyard hooligans? If we are keeping score in Gorlitz's battle of mind, soul, spirit, then intellect is clearly ahead.

Will Gorlitz: nowhere if not here

Literatus

Literatus with Vessel (1989) presents a perplexing scene: crumpled pages strewn on the shore, seed sown upon rocks. The pages float on the water like flowers scattered on the sea in a maritime burial. They surround the vessel—the Bride and her Bachelors—a bowl, or basin (a term for a body of water) shiny as the reflection of a celestial orb, moon or sun. Is it to be used in our mind's eye to draw water to drink, a vehicle to gather for cleansing, or the sunken hull of another type of vessel: a wreck?

Can we be sure of anything? In what direction is the action occurring? Were the pages carried to the shore in the vessel (by the Literatus) and then dropped, thrown? Is the vessel the vehicle intended to be used to gather them up? What message do these scattered pages hold? Their grisaille countenance is indecipherable as either image or text. What in this picture is intended to be referred to by the term "literatus" from the painting's title? A literatus is a man of letters; in this picture literature literally litters the shore. The title and picture pose a niggling enigma that we want to solve. Alas, we are propelled further away from the mundane questions: How did this scene come to be? Who dropped these things? I find myself speculating: Is this constellation of strewn scraps a reenactment of the big bang in a puddle? A tempest in a teapot? The Book of Ecclesiastes advises us to "Cast thy bread upon the waters: for thou shalt find it after many days." Are we being asked to have faith to cast away the safety net of the mind and surrender to belief?

The scene is bathed in the even-handed light of midday, blanched, unremarkable in colour and tone. Arthur Lismer came to Canada's rocky Atlantic coast to contemplate and capture in his works a microcosm of the universe, nature's treasures caught in tidal pools. Gorlitz offers no starfish or seashells to distract.

Are the pages of the literatus emblematic of intellect and learning? Are they intended to play off against the vessel, emblematic of the sphere of hand-driven trades and earthbound labours: drawers of water, hewers of wood? The clinical stainless-steel bowl catches a glint of the sun, creating a sundial, a clock face, and then flickers into an alchemical burst of light. Does this transmorph in the companion painting, *Literatus with Flames*? Loose-leaf pages—castaways on the shore, dust in the wind—alight, scatter and tumble, smoulder, and then catch fire. Is this more burning book bashing or else a precursor to a burning bush?

I suppose one could consider *Literatus with Vessel* a contemporary closeted rendition drawn from the stock arsenal of the romantic painter: moon over water. I want to consider these works solely within the genre of compelling landscape art, but then again Gorlitz has got me thinking.

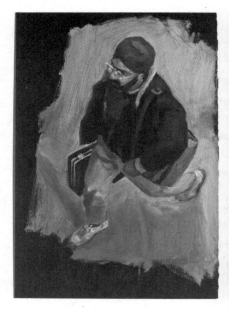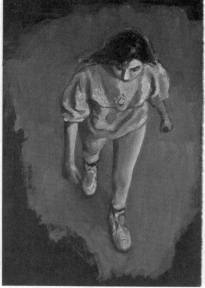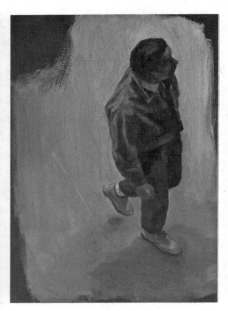

Not Everyone (details)

Not Everyone (1991)

The series *Not Everyone* places Gorlitz in the high-handed position of looking down upon teeming humanity. One could postulate that in the spirit of Chuck Close, Thomas Ruff, or the late-career portraits of Andy Warhol, *Not Everyone* intends to capture chance democratic portraits of ordinary people. However, the subjects, caught off guard, as if glimpsed from some overhead security camera, their grey tonality leaches out their lifeblood, rendering their personhood neutral. Painted on a resilient steel support, it hardens our perspective. This is humanity as if seen from space—ants, inconsequential: the individual everyman as a nobody.

I want to believe *Not Everyone* is a critique, a rallying cry against clinical coldness. Does its example compel us to action, to push back against the intrusive forces of authority—governments, big business, Big Brother, individuals governed by larger forces, destinies and powers? Instead I worry that this work is indicative of Gorlitz's chosen and preferred vantage. In this and many other works, his viewpoint is separated from the common ground; he gazes from afar upon the daily affairs of mankind with a supreme indifference—non-judgmental, noncommittal, non-interventionist. Viewing humanity at a safe distance as an onlooker and noncombatant, Gorlitz is the creator (well, perhaps as the Creator from *The Truman Show*). The images are startling in their apparent lack of warmth and compassion for his fellow beings. This lack is unsettling, and if this is where this thinking leads, I may not want to go down this path.

Grassfire (1994)

Out from under the paucity of passion, the *Grassfire* paintings ignite: dry, spent grass kindled in a spontaneous outburst. The sheer size of the works overwhelms and engulfs, causing viewers to come to a full stop. This is not a wildfire, a ravaging menace; it is contained, limited. It is nature's means of cleansing and resurrecting. A natural cycle: birth, maturity, decline, decay, and death followed by the pyric promise of renewal. What has transpired? One might speculate that momentous events in Gorlitz's life shook him and lead him to an urgently altered philosophical view of life and artistic posture.

These are paintings on a grand scale, reaching skyward, painted masterfully, with confidence and exuberance. They stand comparison with the great icons of Canadian painting. They summon distant recollections of past art. In the history of pioneer Canada one thinks of the astonishing paintings of Joseph Légaré that chronicle the great fire at Quebec City. Both Gorlitz and Légaré play upon our morbid fascination with the forces of nature to intercede and wreak havoc upon our existence. Yet we are mesmerized by the terrifying awe of its transformative power. The *Grassfires* send me off in all directions, drawing in all manner of tangential references, Whitman's *Leaves of Grass*, religious resurrection iconography in general and Grunwald's Isenheim altarpiece in particular, and the spiritual, metaphysical later art of Lawren Harris. Metaphors spring to mind, but nothing to be firmly pinned. Nature can regenerate, life commences afresh, arises again from the earth—everything, that is, except us. We pass on. We are left to ponder.

The *Grassfire* paintings are less clever than Gorlitz's earlier works. They are less intellectually insistent upon eliciting specific topical and timely dialogue, less insistent that we recognize their gravitas. Yet these small fires resonate with import. They give pause; glimpses of the divine, moments of quiet reflection; we are shown to be vulnerable. Through them we gain entry, we peel back the layers to acknowledge certain inescapable realities, an inner reflection upon our place in life's continuum.

Numerals (1995)

A crisp breeze rustles through the Ontario woodland. In the brisk chill, summer gives way, sending a cascade of yellow heart-shaped aspen leaves fluttering downward. It is autumn in Canada. In a slow-moving brook, leaves like tiny life rafts are buoyed upon the cold dark-blue-violet waters of late afternoon. They pirouette in the gentle current, they come to rest in pools, entangling their stems, aligning in a cluster that reflects patterns bidden by an undercurrent. This is a scenario that Gorlitz might have extracted directly from an admiration for the grand tradition of Canadian

landscape painting. A.Y. Jackson's *Red Maple* (1914), Arthur Lismer's *Sackville River* (1917), and particularly J.E.H. MacDonald's *Leaves in the Brook* (ca. 1918) are evident pictorial precedents.

For centuries chance natural configurations such as this have occasioned introspection, contemplation, and gentle reverie. Narcissus, Paul Peel's *Little Shepherdess*, Leonardo, artists of the ages—all have come to gaze in quiet thought upon the messages that live in the chance markings and ripples of a reflective pool, in billowing clouds, in patterns upon cave walls; all act as the wellspring for imagination. A fortuitous coalescing of forms advances a thought: Is that a face I see? A sweet recollection? In the world of Will Gorlitz, nature cooperates to create a curious circumstance. Though there may be no perceivable order in the universe, aspen leaves, at least, stack up in numerical sequence. Each painting can, when seen in individual panels, momentarily suspend evident identifiable reading; they are organic asymmetrical confluences. Then the magic revelation: a connect-the-dot moment: Is that the number 4? Momentarily the illusion holds until the stream disrupts the pattern, the leaves glide on, some sink below the surface; the message is scattered in disarray. The marvel and the joy is the unexpected discovery of a chance subliminal communication.

Gorlitz's *Numerals*, however, leave little to happenstance. He arranges all the paintings into account: 0 through 9. Why is he so eager for us to decode? Why not make the images a little more oblique? Why not risk that we might not get it? Nature's mystery is subjugated to the human intellect: once again it is mind over matter. *Numerals* are works of unquestionable wit, and a great contribution to our art. Why does all this certainty disappoint?

Within the context of this overview exhibition we might have benefited from seeing a selection of recent works that returned to the aspen motif. At Birch Libralato Gallery, in Toronto, in 2005, Gorlitz displayed a group of works all titled *Aspen Leaves* (2005), in which he overturned the expectation that paintings conform to a rectilinear enclosing format. The works are all on panel cut in irregular shapes. Throughout his work Gorlitz has shown awareness that the painting as object stamps itself upon the gallery wall. This enclosing shape both contains and confines the image as well as the marks upon it. Further, it aligns the painting with the perceptual reading of the "painting as window frame," and its content "a picture" subject to expected rules of linear and aerial perspective.

Painters have evolved conventions governing composition to assist them in determining the placement of elements within rectilinear formats in the hope of achieving symmetries and balance. Square and rectangular painting shapes stamp themselves as emphatic gestalts upon the wall: the physical painting object acting as the "figure" to the wall's "ground." The double rationality of rectilinear orderliness within the containing shape of both the canvas and the walls constrain and inhibit our free float beyond the picture boundaries. We recede deep into painterly space.

The modernist tradition has taken all sorts of stabs at liberating picture making from this norm. Geometrical formats are anathema to expressionist abstract painters—Harold Town decried the "tyranny of the corners" and other artists have wondered what to do with the leftover bits that are not central to the action. In figure/ground painting, the hierarchy asserts that the subject is more important than the background. Monet challenged this assumption with the enormous size of his *Water Lilies* canvasses, as did Takao Tanabe with his radically horizontal-format paintings. Both attempted to create new types of pictorial experiences by challenging our ability to grasp the entire picture while pictorial incidents play out on the edges of our peripheral vision.

Similarly, Gorlitz's *Aspen* pictures of 2005 play with this standard reading. Their irregular shapes allow us to enter and exit the these works from different angles. Sometimes we enter face-on, at other times obliquely: the picture plane tilts back and forth. The centre of the picture is the centre of attention, while the perimeter fades out of immediate consideration.

The arrangement of the leaves appears happenstance, a perchance scattering. Perhaps we had better forget art historians and seek the advice of those practised in the art of tea-leaf reading. By some strange twist of serendipity the current in the stream assembles the leaves into a pattern, and gradually our gaze perceives within the inchoate massing of leaves a message. Does *Aspen Leaves* spell out the word "WHY?" I have tried to demonstrate that this is so to numerous souls, only to find them turning away incredulously. But to me it is there. It is important that it is there, even though I can't categorically demonstrate its existence. The picture leads me to contemplate even larger philosophic questions: fall, transitions, beginnings, and endings. Can we divine our own fortune and destiny?

In other works in the series, do I detect left–right reversal writing, an image of Orion? Yellow aspens glittering on blue form an earthly, watery reflection of stellar constellations, Van Gogh's *Starry Night*. Am I now just *Will*-fully seeing? *Aspen Leaves* (2007) drops all of the wordplay and compositional gymnastics. Is it enough that leaves float upon indeterminate space above dark pools of sunken leaves? Aspen leaves atop blue-black shimmering reflections on water spelling out petroglyph-like forms stir a recollection of our shared human legacy concerning first rudimentary spiritual questions.

Axis Mundi (1995)

Trees are ubiquitous in Canadian art, all the more reason to be impressed by the qualities of *Axis Mundi*. In the painting *Scorned as Timber, Beloved of the Sky*, Emily Carr decries the scourge of man upon wilderness while holding out hope through metaphysical speculation. *Scorned* may have established the gold standard for

pictures looking skyward through a screen of trees. *Axis Mundi* celebrates an ordinary grove. The trunks of the trees soar to an apex, transmuting the scene into a living cathedral. The rendering of the foliage is not quite specific enough for a generalist to determine the tree type, but I want them to read the trees as sugar maples and so call to mind a resonance with the era of the Group of Seven. When I squint it can work. Certainly these are not mighty oaks or redwoods. This grand effect is achieved in a depiction of modest-scaled deciduous trees. We gaze into the beyond, as if lying flat on our backs in a kind of supplication to the grand spectacle of light filtering through tree boughs—a day off, simple pleasures. Its compositional scatter admirably emulates with understatement the abstract art of Les Automatistes. Sun slants through upper limbs, turning some leaves golden-yellow while casting lovely blue-violet shadows elsewhere.

This surface visual impact might be more than sufficient for any picture and no further ink need be spilled to attest to its commendable experiential properties. But then there is the title: *Axis Mundi*. It infers a world of discussion and deliberation. Axis mundi is a symbol that has for centuries embraced a wealth of meaning: a concept to articulate a world axis, a centre of the universe, our own native land as centre, a place where we encounter on earth a pathway to heaven. It also invokes the idea of a world tree, a shamanic healer, and inspired the universal symbol for medicine—an axis or spire (as in a church steeple, skyscraper, landmark, or mountain peak). The painter delivers to us a requirement, by virtue of naming his picture *Axis Mundi,* to alter our relationship with the image he presents. A glorious afternoon spent under the canopy of a stand of trees must now bear the burden as source of speculation linking us to world knowledge and the divine.

As we view a number of works from the related series, it becomes apparent that these are trees in a Canadian forest. Most feature sunlight as the method of transformation, turning the ordinary into the glorious, green leaves into gold. Some of the images make it more explicit that the time of year is the transition to fall—some bare branches, some leaves turned yellow and brown. Canada is Gorlitz's axis mundi just as nature and the fall are central to Canada's art. Sun streams through the central trunk and limbs of *Now* (2001), converting the copse of trees into a remake of Rembrandt's *De Drie Bomen.*

Gorlitz sometimes overreaches. His accomplishments as a *painter* are exquisite. Sans title, the painting would be an engaging work worthy of endless reflection, ready to stand on its own as an experience offered for our contemplation. His poetic, painterly treatment of the trees forecasts the potential range of reactions of any reasonably sensitive viewer. The title asks that we interpret in our reading; it asserts that the artist is thoughtful and knowledgeable. Specifically, it signals that his mission and message is intellectual rather than sensory. It seems he is uncomfortable with the notion that perceptual art could outflank conceptual art. Yet his

work demonstrates that painting is a medium that can convey important non-verbal messages—messages that can achieve their aims without illustration of or deference to literature, sociology, politics, or philosophy.

Five Oceans (1996) / *Peripherum View* (1996)

Five Oceans is a clever project, succinct as an idea, quickly graspable. The word *Ocean* is spelled out over five panels by selecting one letter from the name of each of the five oceans, depicted as it appears on the globe. Gorlitz records the specific colouration and striations plus their longitudinal and latitudinal demarcations. The lettering, shown in parallax view, plus the subtle hue and tonal variations make for an elegant, handsome presentation. As bonus, we are reminded via the work that the waters of the five oceans flow seamlessly into one another, one continuous body of water named separately for its specific locale, yet ultimately one expanse of water: one ocean.

Logic dictates that *Peripherum View III* ought to read as a portrayal of a globe on the schoolmaster's desktop. At first view it might engage the spirit of Jasper Johns's lavishly painted heraldic maps or else Greg Curnoe's politically impish *Map of North America*. Perception inverts expectation, however. The scale is disorienting. The two canvases imply a sphere that is gigantic in proportions. They free-float on the wall, at an angle, neither aligned parallel to the floor nor subject to gravity. We enter the left (lower) panel and flow up to the other panel with the motion dictated by the arrangement. It sets us spinning. As conceived by Gorlitz, we encounter a dreamlike visage.

He sets our orientation. This unearthly depiction is as if viewed from an orbiting space station. Earth, our floating orb, is the centre of the dark vacuum of the universe, no moon, no stars. The resolute blackness presents the heavens as unknowable, while our earthly bounds are neatly chronicled as provinces and territories by boundaries, as places named and thereby known. Canada is the heart of the pink

planet (the colour selected, of course, as the hue designating the commonwealth; it should be noted that it heats to red at the peripherum border). The vista sets a course over top of Canada's north and presents a topsy-turvy, unfamiliar national portrait, our Canadian axis mundi. We are positioned in the world in stark global isolation: no Europe, no Russia, no China, no stars and stripes. We are sky travellers retracing the search for the Northwest Passage, global issues glimpsed askance.

Road Paintings (1997–98)

Coming back to earth, Gorlitz commenced a series of country road paintings, another travelogue of sorts. Remarkable in the ordinariness of the selected scenes, they seem neither picturesque nor notable as places in any immediately evident way. As views, they are as generic as the people in *Not Everyone*—paintings of "no places" and no time, and in particular, moderated, impoverished colour.

Granted that local zeal will inspire patriotic embrace of even the most humble views, these are still pretty plain-Jane. Certainly Dorothy Knowles made a virtue as well as a career out of depicting every nook, cranny, and nuance of prairie Saskatchewan. I just didn't expect Gorlitz to trumpet the virtues of back-road Ontario. John Ruskin advised painters to reinvigorate their art by rejecting first inclination to depict "beauty spots." If one selected scenes to depict in response to intuition, he warned, one is lead invariably to stereotypical compositional solutions. Instead, he admonished, find a compelling picturesque view, turn 180 degrees away from it, and depict the overlooked.

Gorlitz's roads cut a swath through nature, bounded by fences and power lines. Mediated by the windscreen of an automobile interior, views such as these are nevertheless, for too many of us, our most authentic encounter with wilderness, nature, and the outdoors. Just steps from the roadway may lie wondrous private worlds, but they remain unvisited. Our sense of a place is charted from a road well travelled, understated landscapes, everyplace and no place. These paintings confuse me. Seasonally indeterminate, are they winter's beginning or end? They are pictures of land in waiting, in limbo, hibernation. I search for the guidance of a title to steer me, only to find the titles generic. I asked for it, I got it, but now I'm lost.

As It Is

A camera dropped into water, sinking below the surface, partly submerged, it casts ripples, concentric rings, distorting its image. The heart quickens: Could this be a declaration of the death of photography? Photographic representational precision blurred by the veil of water. Is this a parable of painting and subjectivity? Who dropped photography? *Thy will be done on earth, as it is in heaven.*

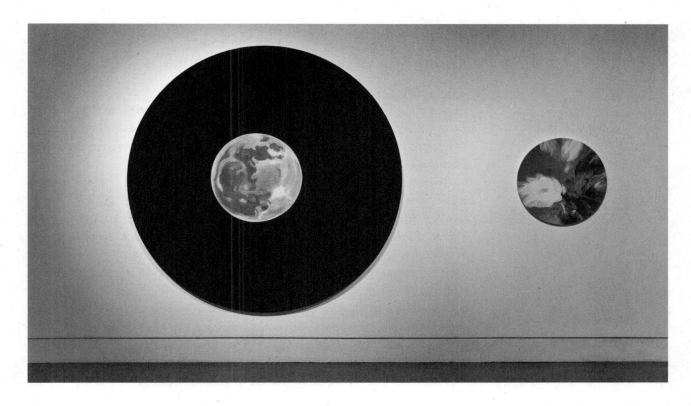

Moon Centre and *March*

Concentric circles and vessels frequently figure as protagonists in the artist's painterly narratives: the globe, moon, rings bounded within a tondo-shaped canvas. Bowls, cups, and vases: Are they a chalice (the *Da Vinci Code* chalice?). Anyone who draws overripe fruit in conjunction with Freudian text is fair game for sexual sport. In this exhibition the moon paintings are paired with the tondo *March* (2002), a floral image blurred and distended, perhaps plunged into water. The moon paintings (1997) allow the artist licence to command the moon to perform visual illusions. Their images double and misalign, as if seen through unfocused binoculars. Or could it be that we are looking at molecular imagery rather than celestial? Why is *Moon Centre* (2002) off-centre?

Caspar David Friedrich's monk, standing at the edge of the sea, looks to the heavens seeking solitude, away from the affairs of civilization and the works of man. We find the moon paintings of John Clark and Paterson Ewen in the same tradition, creating works that seek solace and communion through "aloneness with God." The moons of Gorlitz drift in a starless sky, solo, unaccompanied, "loneness without God."

Does Gorlitz's moon still exert effect on our affairs here on earth? Does it have spiritual pull, emotional sway? I wonder why I can't shake the thought that *Moon Centre* (2002) is a semblance of a vinyl record album, and then it shifts and it is an eye/iris. We have collectively spilled a sea of words waxing eloquent to the moon in vain attempt to express emotional longing and wistful regret.

Shattering Vases with Flowers (2005)

Often Gorlitz sets his sights on high, gazes into space, we look down from above. Just as often, things take a tumble: literatus, dropped and dispersed, camera and flowers plunged into water. Aspen leaves are released from the tree and are fallen. At his 2005 exhibition at Birch Libralato Gallery, these fall pictures were paired with paintings of shattering vases with flowers.

The orb falls to earth. Hard and brittle, the ceramic container shatters. In these pictures, however, the vases do not fall to the floor or find home in a specific earthly location. The action appears to occur in mid-air. They have struck painterly ground, shards radiate outward, propelled into pictorial space. They form dynamic moving constellations emanating from the floral centre. The backdrop is formed by swirls of dense opaque impasto paint creating a pool of lugubrious chromatic neutrals and grey.

Cut flowers live on in the host vessel, a container holding water. But now that the vessel is broken, the flowers—fish out of water, life fleeting, their beauty relegated to the past—are splayed and move from foreground to background. Like the yellow aspen leaves cast upon water, the finality of their end is now evident: momento mori. Why then don't the paintings appear angry, urgent, or agitated? Beauty is beaten; life has been snatched by miscue. One might expect the paintings to be animated, electrically charged, or gripped by emotion. Yet the paintings express neither that we should be startled by the violent overturn, saddened by the mishap, or mourn the loss. Just as with *Literatus with Vessel,* we aren't provided enough clues to tell who took this action and why it happened. Nevertheless, we cannot escape the gravitational pull toward romantic projections. Dead flowers offered as expressions of love and celebration as well as an offer of solace, an expression of regret. Beginnings and endings.

I am enticed by the tenderness of the painted passages of these works. The Gorlitz family has endured momentous, tragic loss, and the artist himself faced threatening medical challenges. These disruptive incidents shake us to the core and deflect us from our course; we need heed their warning. We are visited by a tiny melancholy, a fleeting glimpse of an irrefutable, unavoidable truth. We become self-conscious, aware of our own fallibility, vulnerability, and inevitable demise. Must this moment of recognition always land us in despair? Must it spell the wreck of hope, the end of trust? We resist the thought that the excellence of the works of the mind must be contained by the frail ever-so-mortal corpus. The body yields to time, the coil of mortality unravels. Are Gorlitz's paintings about the end of time or a new beginning, the big bang revisited? The divine one drops the ball; Gorlitz asks the question *Why?*

Cooler heads won't settle such questions. The current works of Will Gorlitz make their case upon other strengths. The paintings ask us to ponder the unknowable,

grapple with the grand questions of meaning and purpose. Gorlitz is a seeker, exploring the vast unfamiliar universes to be glimpsed at the opposite ends of the telescope and the microscope. Intellect can't save you here. Shattered vases, scattered flowers cast into the void, prayers to a godless universe.

Jeffrey Spalding

Jeffrey Spalding is a curator, critical writer, and artist. He is President of the Royal Canadian Academy and received the Order of Canada in 2008.

DAVID URBAN

The Bird Machine and
the Glory of the Real

We have seen that when the earth had to be prepared for the habitation of man, a veil, as it were joined, in a subdued measure, the stability and insensibility of the earth, and the passion and perishing of mankind. But the heavens, also, had to be prepared for his habitation. Between their burning light,—their deep vacuity, and man, as between the earth's gloom of iron substance, and man, a veil had to be spread of intermediate being;—which should appease the unendurable glory to the level of human feebleness, and sign the changeless motion of the heavens with a semblance of human vicissitude. Between the earth and man arose the leaf. Between the heaven and man came the cloud. His life being partly as the falling leaf, and partly as the flying vapour.

—John Ruskin, in *Modern Painters*

IN STATING THAT THE HUMAN PSYCHE IS DIVIDED BETWEEN THE leaf and the cloud—two motifs that happen to thread throughout the work of Will Gorlitz—Ruskin identifies the essence of modern painting: a desire to represent the "unendurable glory" of the cosmos in tandem with "human feebleness." Like Ruskin, Gorlitz posits an art that includes both kinds of consciousness;

the scale of his work intends to encompass both changeless motion and human vi-cissitudes in equal measure. This holistic striving is rare in contemporary art, which has fetishized an ersatz idea of newness at the expense of the kind of healing insights that an art like Gorlitz's offers.

In the new millennium the categorical distinctions between the real and the abstract or virtual have come under increasing pressure and might even be said to be in a state of collapse. Within the practice of painting as well, the notions of abstraction and realism have lost their hegemony; although joined at the hip at the beginning of the twentieth century the two practices have drifted unreasonably apart over the ensuing years. The painting of Will Gorlitz has long predicted this current crisis, residing as it does in the solitude of a sustained and intense engagement with observation, the translation of optical into pictorial reality, and in the wonderment that such contemplation engenders.

What is *the real*? In the painting of Gorlitz the answer is twofold; the real is both the bounty of the world as we perceive it and an existential proposition—the chimera of sight, the ever-changing, infinite, and finally unknowable abyss that stands just beyond everything that we are able to see. I have long found the same solace in Gorlitz's work as I have in many of my favourite poets—Philip Levine, George Oppen, W.C. Williams. Like these poets, Gorlitz practises a poetry of the familiar. This is not to say that he is mired in the quotidian; quite the opposite, in fact. It is, rather, that under his gaze the world as it is given to us acquires a sheen of mystery—he reawakens in us a desire to perceive and connect with the world that is latent but seldom engaged. The nature of Gorlitz's gaze is paradoxical; it seems to be equal parts curiosity and philosophical aloofness. The childlike will toward pure perception is always tempered by the lens of experience and its need for abeyance. The resulting clarity of vision is a hallmark of Gorlitz's work. It suffuses his world and leaves us with a new way to look at ours—pointing us away from banality and toward the motive for metaphor, to a place where the tropes of the familiar are wiped clean and renewed.

Gorlitz underscores his commitment to existential contingency by scrupulously avoiding the grand composition. Where one artist might typically frame his view, Gorlitz will instead direct us just to the side, behind, or even upwards. Sometimes, as in the case of the *Peripherum* and *Road* paintings, Gorlitz's discursive gaze adopts a fractal logic, discarding the harmony of a single frame and in doing so demonstrating the mechanics and multiplicity of the eyes' attempts to comprehend. Frequently Gorlitz's subject matter is impossible to fully capture and mercurial in nature: he will set out to capture a sudden flare of light from behind a branch, the arc of a glass vase shattering and scattering flowers, the look of a text submerged in water, the moon as it blurs under our scrutiny. These are less subjects than they are moments—moments in which the philosophical and the optical coalesce. Again, it is not an

attempt at metaphor that Gorlitz is seeking here; he is trying to picture the event itself. Through meticulous and steady description he seeks to supplant the sudden or haphazard with its fully articulated analogue; as in Beckett's *Molloy,* where the profusion of words amounts to a portrait of consciousness itself, Gorlitz's brush articulates how the most ephemeral and disregarded visions can be fraught with personal and collective meaning.

To understand this is to understand the nature of a significant artist. Gorlitz is not trying to show us anything. He is trying to find out. We are as present in the consciousness of his paintings as he is. Everything is laid out before us, each vision and revision, every inch of the canvas is impacted by his thought. It bears repeating that the only way to embody thought in painting occurs at the surface level, in the paintings' facture. A painting's subject matter can be animated and enlivened only at this level, otherwise it has no consequence or meaning. This chain of meaning is similar to the creation of a poetic line; it is the sense, sound, and symmetry of the words that embody the thought. Similarly, it is the brush that articulates the paintings' intent. In an age that equates passion with flamboyance and nonchalance, it might at first be difficult to perceive the passionate nature of Gorlitz's enterprise. Nonetheless, it is only against this backdrop of profound restraint—a restraint that values the most intimate gestures over the hyperbolic and self-aggrandizing—in which Gorlitz's ambitious concerns acquire their power and resonance. In this sense, Gorlitz's paintings ask more of us than most, and we must meet them at least halfway. The quiet integrity of the images asks us for and rewards a congruent inner scale, otherwise the images are content to lead their own intricate lives, growing silently in our obliviousness.

Perhaps, rather than construing painting's poles as between the mimetic and the abstract, we might be better served by looking at things from the structural standpoint of thoughtful painting versus thoughtless painting. Gorlitz embodies the former by having a remarkably coherent painterly strategy. His images are dry, almost always foregrounding the mechanics of the hand and its intimate prosthesis: the bristle brush. The paint is applied judiciously and is always congruent to the images' needs. It is always possible to recreate the relative speed of the paintings' execution, and decisions in composition, placement, and scale are readily apparent because this is a remarkably naked type of painting. Nothing is hidden or deliberately obfuscated. One senses the considerable forethought in each image because each stands as the ossified trace of a worthy struggle or it otherwise has no right to *be.* Colour is local, by and large, with expressionistic touches and haloes that are apparent only to the committed viewer. The approach is fundamentally respectful—respectful of the viewer's time and efforts and respectful of painting's expressive potential. In looking at a Gorlitz one can trace an unbroken line through the lucid allegories of the Northern Renaissance through twentieth-century Britain and artists such as Sickert,

Spencer, and on to other luminaries such as Uglow, Freud, and Thomson. Despite the erudition of Gorlitz's approach, one never feels the burden of history—his work points firmly toward a future redeemed by the best of our artistic past.

Gorlitz's oeuvre is simultaneously beholden to and suspicious of photographic imperatives. Unlike many contemporary artists whose work embraces mimesis and revels in its indebtedness to photography and pop culture, Gorlitz has a nuanced and deliberately complex relationship to photography. Even in the early work, which is clearly sourced from photography, it is painting rather than photography that presides as the metaphorical ghost in the image. In fact, one might characterize Gorlitz's work as anti-photographic. It is anti-photographic not because it rejects the technology but because it is so acutely aware of its limitations; it is as if Gorlitz has chosen to amplify the very qualities that differentiate the two media. In a painting such as *White Irises, Yellow Vase*, it is easy to discern the myriad small distortions that are emblematic of the eyes' roving journey. The painting's dim space is simultaneously earthy and intangible, like that of a Rembrandt portrait. On this indeterminate stage the motif of the shattering vase literally erupts, illuminating the painting in the paradoxical light of creation (and destruction). We realize in this instant the often convergent paths of sadness and beauty. How fragile the yellow of the vase, how ghostly the white petals: trembling, they are already shadows of themselves. The path chosen by Gorlitz here is heroic—he wants nothing less than the glorious instant fully reified in paint, and he knows that anything less would compromise this communal moment—a moment in which the subject, for audience and artist alike, acquires the vivacity and lustre of the thing itself—and the ability to let the fullness of its meanings unfold, permanently, in the chaotic present. For Gorlitz, this journey is necessarily tinctured by an ethical dimension; he asks that we undertake, in real time, a reconstruction full of the same bumps, flares, and ligatures that constitute his search for the real. Here, as elsewhere in Gorlitz's work, it is the humanistic tradition that haunts the emaciated, mediated present.

I recently took my eight-year-old son to the science museum. Looming above us, in the hall of natural history, a strange apparatus caught our eye. Intrigued by the sounds of birdsong and rustling leaves, we found ourselves climbing up a spiral staircase to investigate. At the top a sign announced the presence of Into the Skies, an exhibit that attempts to simulate the flight of a bird, recreating in film and sound the intense and dizzying sensations of an oriole's flight. Lying on his stomach, on a promontory suspended twenty feet above the ground, my son apprehensively began looking through a viewfinder cut into the floor. As I cautiously climbed out and lay down on the steel frame with him I experienced something of an epiphany regarding Will Gorlitz's paintings. Here was the same curious disembodiment, the same mercurial exhilaration—flying up through branches, blinded suddenly by strong light and then the bracing reprieve of endless clear blue. It was as if the bird machine

had revealed something essential about painting and Gorlitz's oeuvre. It is not often stated, and certainly not common in an age as fatuously material as ours, but the finest painting has often attempted a kind of consciousness that goes beyond the individual. Despite the consistency of Gorlitz's thematic material, the overarching feeling that his painting imparts is of just such a consciousness; animalistic, as in the intelligence of animals, free—in the avian sense—and governed by a fierce logic that always senses something beyond itself.

David Urban
Toronto, Ontario

———————————————

David Urban is an artist, an independent curator, and a critical writer.

List of Works

1 *As It Is*, 1991
Oil on canvas (38 × 51 cm)
Collection of the artist

EXHIBITION HISTORY:
Galerie René Blouin, Montreal, 1991
Galerie de l'UQAM, Montreal, 2003

2 *Literatus with Vessel*, 1989
Oil on canvas (201 × 267 cm)
Collection of the artist

EXHIBITION HISTORY:
National Gallery of Canada, Ottawa, 1989
Sable-Castelli Gallery, Toronto, 1990

3 *Literatus with Flames*, 1989
Oil on canvas (201 × 267 cm)
Private collection

EXHIBITION HISTORY:
National Gallery of Canada, Ottawa, 1989
Sable-Castelli Gallery, Toronto, 1990

4 *Axis Mundi*, 1995
Oil on canvas (125 × 214 cm)
Collection of the artist

EXHIBITION HISTORY:
Galerie René Blouin, Montreal, 1996
Macdonald Stewart Art Centre, 2004

5 *Grassfire (Fifth Burning Grass)*, 1993
Oil on canvas (97 × 53 cm)
Collection of Peter Blendell and Buffy
Carruthers

EXHIBITION HISTORY:
Sable-Castelli Gallery, Toronto, 1994

6 *Double Negative: Two Densities*, 1997
Oil on canvas (41 × 51 cm)
Collection of Steve Smart

EXHIBITION HISTORY:
Sable-Castelli Gallery, Toronto, 1998

7 *Double Negative: Transparency*, 1997
Oil on canvas (46 × 61 cm)
Collection of the artist

EXHIBITION HISTORY:
Sable-Castelli Gallery, Toronto, 1998

8 *Three Essays on the Theory of Sexuality*, 1989
Oil pastel and text on paper (75 × 696 cm)
Collection of Winnipeg Art Gallery

EXHIBITION HISTORY:
Artspeak Gallery, Vancouver, 1989
Sable-Castelli Gallery, Toronto, 1990
Birch Libralato, Toronto, 2005
Winnipeg Art Gallery, 2007

9 *Numerals*, 2008
Oil on canvas (10 units; each 43 × 53.5 cm;
variable installation dimension)
Courtesy of Birch Libralato, Toronto

10 *Not Everyone*, 1991
Oil on steel (43 cm high, variable width)
Collection of Agnes Etherington Centre,
Kingston

EXHIBITION HISTORY:
Agnes Etherington Centre, 1991
Sable-Castelli Gallery, Toronto, 1991

11 *Peripherum View III*, 1996
Oil on canvas, diptych (229 × 203 cm)
Gift of the artist, 2001, University of Guelph
Collection, Macdonald Stewart Art Centre,
Guelph

EXHIBITION HISTORY:
Sable-Castelli Gallery, Toronto, 1996
Macdonald Stewart Art Centre, Guelph, 2002

12 *Peripherum View I*, 1996
Oil on canvas, diptych (115 × 253 cm)
Collection of the artist

EXHIBITION HISTORY:
Sable-Castelli Gallery, Toronto, 1996
Shanghai Art Museum, Shanghai, China, 2002

13 *Five Oceans*, 1996
Oil on canvas (5 pieces, 38 × 54 cm)
Collection of Richard and Sandra Unruh

EXHIBITION HISTORY:
Sable-Castelli Gallery, Toronto, 1996

14 *Road Near Glenora (Autumn)*, 1997
Oil on canvas, diptych (64 × 135 cm)
Collection of the artist

EXHIBITION HISTORY:
Sable-Castelli Gallery, Toronto, 1998
Galerie René Blouin, 1999
Elora Centre for the Arts, 2006

15 *Road Near Madoc*, 1998
Oil on canvas, diptych (61 × 134 cm)
Collection of OMERS

EXHIBITION HISTORY:
Sable-Castelli Gallery, Toronto, 1998
Art Gallery of North York, 2002
Collection of Omers

16 *Road Near Carrying Place*, 1998
Oil on canvas, diptych (72 × 122 cm)
Collection of Harold Klunder

EXHIBITION HISTORY:
Galerie René Blouin, Montreal, 1999
Art Gallery of North York, 2002

17 *Road Near Wellington*, 1999
Oil on canvas, diptych (90 × 122 cm)
Collection of Pat and Chris Harman

EXHIBITION HISTORY:
Galerie René Blouin, Montreal, 1999

18 *Moon Centre*, 2002
Oil on canvas (201 cm tondo)
Gift of the artist, 2007, Macdonald Stewart Art
Centre Collection

EXHIBITION HISTORY:
Galerie René Blouin, Montreal, 2004
Sable Castelli Gallery, Toronto, 2002
Museum of Contemporary Canadian Art, 2003

19 *March*, 2002
Oil on canvas (122 cm tondo)
Collection of the artist

EXHIBITION HISTORY:
Galerie René Blouin, 2004
Kitchener-Waterloo Art Gallery, Kitchener,
2004
Museum of Contemporary Canadian Art, 2003

20 *Pink Peony / White Vase*, 2005
Oil on canvas (63 × 48 cm)
Courtesy of Birch Libralato

EXHIBITION HISTORY:
Birch Libralato, Toronto, 2005

21 *White Irises / Yellow Vase*, 2005
Oil on canvas (72 × 60 cm)
Courtesy of Birch Libralato

EXHIBITION HISTORY:
Birch Libralato, Toronto, 2005

22 *Red Roses / Blue Vase*, 2005
Oil on canvas (72 × 60 cm)
Collection of Mr. Sturla Bruun-Meyer

EXHIBITION HISTORY:
Birch Libralato, Toronto, 2005

APPENDIX TWO

Curriculum Vitae

Solo Exhibitions

2008 (2005)	Birch Libralato, Toronto, Ontario
2007	Winnipeg Art Gallery, Winnipeg, Manitoba
2007	Harbinger Gallery, Waterloo, Ontario
2004 (1999, 1996, 1991)	Galerie René Blouin, Montreal, Quebec
2002 (1998, 1996, 1994, 1992, 1991, 1990, 1988, 1987, 1986, 1985, 1983)	Sable-Castelli Gallery, Toronto, Ontario
1994	Power Plant Contemporary Art Gallery, Toronto, Ontario
1991	Centre culturel canadien, Paris, France
1991	Agnes Etherington Art Centre, Kingston, Ontario
1991	McIntosh Gallery, London, Ontario
1990	Oakville Galleries, Oakville, Ontario
1989	Artspeak Gallery, Vancouver, British Columbia
1988	Mendel Art Gallery, Saskatoon, Saskatchewan
1988	Winnipeg Art Gallery, Winnipeg, Manitoba
1988	Concordia University Art Gallery, Montreal, Quebec
1987	49th Parallel, New York, New York
1987	K.A.A.I., Kingston, Ontario
1986	Art Gallery of Ontario, Toronto, Ontario
1984	YYZ Artists' Outlet, Toronto, Ontario
1983 (1980, 1978)	Plug In Inc., Winnipeg, Manitoba
1983	ChromaZone, Toronto, Ontario

Selected Group Exhibitions

2006 Elora Centre for the Arts, Elora, Ontario
Road Trip

2005 Art Gallery of Nova Scotia, Halifax, Nova Scotia
From New Image to New Wave: Legacy of NSCAD in the Seventies

2004 Kitchener-Waterloo Art Gallery, Kitchener, Ontario
Bloom

2004 McMichael, Canadian Art Collection, Kleinburg, Ontario
Identities: Canadian Portraits

2004 Macdonald Stewart Art Centre, Guelph, Ontario
Skies

2003 Galerie de l'UQAM, Université du Québec à Montréal, Montreal, Quebec
Épreuve de Distance

2003 Kitchener-Waterloo Art Gallery, Kitchener, Ontario
1st Annual KW|AG Biennale

2003 Museum of Contemporary Canadian Art, Toronto, Ontario
Painters 15

2002 Shanghai Art Museum, Shanghai, China
Painters 15

2002 Art Gallery of North York, Museum of Contemporary Canadian Art and the Koffler Gallery, Toronto, Ontario
Regarding Landscape

2002 Macdonald Stewart Art Centre, Guelph, Ontario
Guelph 2002: A Celebration of Guelph and Its Artists

2000 London Regional Art and Historical Museums, London, Ontario
The Single Tree

1999 Galerie René Blouin / Galerie Lilian Rodriguez, Montreal, Quebec
Les peintures

1999 MacLaren Art Centre, Barrie, Ontario
Re-imagining Modernism

1997 Trépanier Baer Gallery, Calgary, Alberta
Painting in the 90's Part I: Sandra Meigs / Suzanna Heller / Will Gorlitz

1995 S.L. Simpson Gallery, Toronto, Ontario
Milieu: Of the order of presentation

1993 Galerie René Blouin, Montreal, Quebec
Pierre Dorion /Charles Gagnon / Will Gorlitz

1992 The Art Gallery of Peterborough, Peterborough, Ontario
Tree Designations

1991 Extension Gallery, Toronto, Ontario
A Public Room

1989 The National Gallery of Canada, Ottawa, Ontario
 Canadian Biennial of Contemporary Art
1987 Hallwalls, Buffalo, New York
 Toronto Exchange
1987 Art Gallery of Ontario, Toronto, Ontario
 Written Images
1986 Sable-Castelli Gallery, Toronto, Ontario
 Will Gorlitz / Douglas Kirton
1986 The Art Gallery of Ontario, Toronto, Ontario
 Perspective 86 — Will Gorlitz and Nancy Johnson
1985 São Paulo, Brazil
 São Paulo Bienal
1985 Plug In Inc., Winnipeg, Manitoba
 Plug In Redux
1985 Galerie Walcheturm, Binz 39, Zurich, Switzerland
 Fire and Ice
1985 Art Gallery at Harbourfront, Toronto, Ontario
 Late Capitalism
1985 Aorta, Amsterdam, the Netherlands
 Doppelgänger
1985 Agnes Etherington Art Centre, Kingston, Ontario
 The Allegorical Image
1984 Mercer Union, Toronto, Ontario (circulating)
 Open Space, Victoria, British Columbia
 Contemporary Art Gallery, Vancouver, British Columbia
 80/1/2/3/4 Toronto: Content/Context

Exhibition Catalogues

1985 Grenville, Bruce. *The Allegorical Image in Recent Canadian Painting*
 (Kingston, Ontario: Agnes Etherington Art Centre)
1985 Guest, Tim. *Late Capitalism* (Toronto, Ontario: Art Gallery at Harbourfront)
1985 Wood, William. *Fire and Ice* (Zurich, Switzerland: Galerie Walcheturm, Binz 39)
1985 Rhodes, Richard. *Fractura Narrativa Propria*, São Paulo Bienal (São Paulo,
 Brazil)
1985 Sigurdson, D., and S. Gillies. "Plug in Redux" (Winnipeg, Manitoba: Plug In Inc.)
1985 Groot, Paul. *Doppelgänger* (Amsterdam, the Netherlands: Aorta)
1986 Fischer, Barbara. "Will Gorlitz / Nancy Johnson," *Perspective 86* (Toronto,
 Ontario: Art Gallery of Ontario)
1987 Wood, William. *Will Gorlitz* (New York, New York: 49th Parallel)

1989 Nemiroff, Diana. *Canadian Biennial of Contemporary Art* (Ottawa, Ontario: National Gallery)

1989 McGrath, Jerry. *Three Essays on the Theory of Sexuality – At Home with Freud* (Vancouver, British Columbia: Artspeak Gallery)

1990 Bell Farrell, Carolyn. *The Three Essays Trilogy* (Oakville, Ontario: Oakville Galleries)

1992 Tamplin, Illi-Maria. *Tree Designations* (Peterborough, Ontario: Art Gallery of Peterborough)

1993 Bell, Michael. *Empowering the Word* (Ottawa, Ontario: Carleton University Art Gallery)

1994 Keziere, Russel. "The Troubled Mirror: Will Gorlitz's Real Time," *Real Time* (Toronto, Ontario: Power Plant Art Gallery)

1997 Willson, Kevin. "Will Gorlitz: Drei Abhandlungen zur Sexual Theorie" (Toronto, Ontario: University of Toronto Art Centre)

2000 Millard, Laura. *The Single Tree* (London, Ontario: London Regional Art & Historical Museums)

2005 Falconer, S., C. Finn, and A.L. Freybe. *Identities: Canadian Portraits* (Kleinburg, Ontario: McMichael Canadian Art Collection)

Selected Articles and Reviews

Aquin, Stéphane. "Will Gorlitz", *VOIR* (Montreal), 21–27 March 1996, 50.

Dault, Gary Michael. "The Psychopathology of Everyday Life." *C Magazine* no. 17, (March 1988), 70.

Dault, Julia. "Will Gorlitz." *Border Crossings* 25, no. 1 (March 2006), 108–10.

Dumont, Jean. "Arts Visuels." *Le Devoir* (Montreal), 2 February 1991, C9.

Duncan, Ann. "Brooding Images ..." *The Gazette* (Montreal), 20 February 1988, D5.

Enright, Robert. "The Miss of Sisyphus," *Border Crossings* 21, no. 4 (Fall 2002), 12–13.

———. "Ethics of Uncertainty." *Border Crossings* 17, no. 4 (Fall 1988), 12–25.

Fones, Robert. "Will Gorlitz, Sable-Castelli Gallery." *Vanguard* 15, no. 6 (December/January 1986–87), 29.

Guest, Tim. "80/1/2/3/4, Mercer Union, Toronto." *Vanguard* 13, no. 4 (May 1984), 43–44.

Hakim, Mona. "Le glissement entre l'absence et la presence." *Le Devoir* (Montreal), 2 May 1993, C15.

Klucinakas, Jean. "Will Gorlitz, Galerie René Blouin." *Parachute* no. 63 (July–September 1991), 33–34.

Lebredt, Gordon. "After-Affects: A Small Matter of Some Face." *C Magazine* no. 6 (Summer 1985), 16–19.

Liss, David. "Painting and Seeing," *The Gazette* (Montreal), 23 March 1996, H6.

Loughery, John. "Will Gorlitz, 49th Parallel." *Arts Magazine* 62, no. 4
(December 1987), 10.

Lypchuk, Donna. "Famous Lies and Illustrious Disguises." *Parallelogramme* 2, no. 1
(Fall 1985), 21–26.

MacKay, Gillian. "Will Gorlitz: The Sable-Castelli Gallery/The Power Plant."
Canadian Art 2, no. 1 (Spring 1994), 75–77.

McFadden, David. "Late Capitalism." *Canadian Art* 2, no. 3 (Summer 1985), 18.

McGrath, Jerry. "Will Gorlitz – Axis Mundi." *C Magazine* no. 12, 70–71.

———. "Will Gorlitz." *Vanguard*, February 1984, 105.

McIlroy, Randal. "Gorlitz Exhibit Documents ..." *Winnipeg Free Press*, 24
September 1988, 24.

Murray, Joan. *Canadian Art in the Twentieth Century* (Toronto, ON: Dundurn Press, 1999),
235.

Nind, Sarah. "Will Gorlitz." *Canadian Art* 19, no. 4 (Winter 2002), 82.

O'Brien, Peter. "'Consumed with that which it was nourished by': Will Gorlitz's
Literary Landscapes." *University of Toronto Quarterly* 66, no. 2 (Spring 1997),
403–10.

Punter, Jennie. "The Mundane Made Strange." *The Whig-Standard Magazine*
(Kingston, ON), 19 September 1987.

Rhodes, Richard. "Will Gorlitz." *Montréal*, Fall 1998, 18–19.

Scott, Melanie. "A New Group ..." *Saturday Night*, July–August 1997, 52–60.

Sigurdson, Doug. "Axis Mundi." *On the Arts* [radio interview], CJRT-FM, Toronto, ON,
10 September 1986.

Taylor, Kate. "Odd Couple Stands Art on Its Head." *Globe and Mail*, 29 January 1994,
C17.

Towne, Elke. "Fast Forward." *Canadian Art*, Winter 1989, 32.

Wylie, Liz. "Bad Faith." *Canadian Art* 5, no. 1 (Spring 1988), 96.

———. "Will Gorlitz's Illumination of the Shadows of Doubt." *NOW Magazine*,
10–16 December 1987.

Published Artist Projects

"Excerpt," *C Magazine* no. 4 (Winter 1985), 46–49.

"Cover," *Border/Lines* no. 7/8 (Spring/Summer 1987).

"Left," *Impulse Magazine* 16, no. 1.

"Intersections: NOW Magazine Media Project," *NOW Magazine*, 28 May 1992.

"Will Gorlitz," *Notebook Projects*, Contemporary Art Gallery, Vancouver, BC, 1996.

Published Writing

"Alienation, Painting and Polemics," London Regional Art & Historical Museum,
London, ON, 1999 (Doug Kirton exhibition catalogue)
"The Grandiose Concocted Plan," Stride Gallery, Calgary, AB, 2008 (Art Green
exhibition brochure)

Public Collections

Agnes Etherington Art Centre, Kingston, Ontario
Art Gallery of Nova Scotia, Halifax, Nova Scotia
Art Gallery of Ontario, Toronto, Ontario
Canada Council Art Bank, Ottawa, Ontario
Concordia University Art Gallery, Montreal, Quebec
Glenbow Museum, Calgary, Alberta
Hamilton Art Gallery, Hamilton, Ontario
Macdonald Stewart Art Centre, Guelph, Ontario
Mackenzie Art Gallery, Regina, Saskatchewan
MacLaren Art Centre, Barrie, Ontario
McMichael Canadian Art Collection, Kleinburg, Ontario
Musée des beaux-arts de Montréal, Montreal, Quebec
Museum London, London, Ontario
Shanghai Art Museum, Shanghai, China
Tom Thomson Memorial Art Gallery, Owen Sound, Ontario
University of Toronto Art Centre, Toronto, Ontario
Winnipeg Art Gallery, Winnipeg, Manitoba

Public Art Commissions

Whitby Psychiatric Hospital, Whitby, Ontario
Simcoe Place, Toronto, Ontario
Cineplex Odeon Theatres, Toronto, Ontario

Education

University of Manitoba, Winnipeg, Manitoba, 1972–1975
Nova Scotia College of Art and Design, Halifax, Nova Scotia, 1977, BFA

Academic Appointments

Professor, University of Guelph 2005

Associate Professor, University of Guelph 2001

Honours

Elected member of the Royal Canadian Academy of Art 2005

Distinguished Teaching Award, University of Waterloo 2001

A Walk on the Shoreline

by Rebecca Hainnu · Illustrated by Qin Leng

Published by Inhabit Media Inc.
www.inhabitmedia.com

Inhabit Media Inc. (Iqaluit), P.O. Box 11125, Iqaluit, Nunavut, X0A 1H0
(Toronto), 191 Eglinton Avenue East, Suite 310, Toronto, Ontario, M4P 1K1

Editors: Neil Christopher, Louise Flaherty, and Kelly Ward
Art Director: Danny Christopher
Designer: Astrid Arijanto

Photographs:
Ammuumajut © 2019 Lisa Pirie • Kanajuq © 2019 picturepartners/Shutterstock
Iqaluk © 2019 Dan Bach Kristensen/Shutterstock • Ittiq-Miqqulik © 2019 R. Hibpshman
Ivik © 2019 litchima/Shutterstock • Aqajait © 2019 sigur/Shutterstock
Kuanni © 2019 Sion Roberts

We acknowledge the support of the Canada Council for the Arts for our publishing program.

This project was made possible in part by the Government of Canada.

ISBN: 978-1-77227-269-7

Printed in Canada

Library and Archives Canada Cataloguing in Publication

Title: A walk on the shoreline / by Rebecca Hainnu ; illustrated by Qin Leng.
Names: Hainnu, Rebecca, author. | Leng, Qin, illustrator.
Description: Reprint. Originally published in hardcover in 2015.
Identifiers: Canadiana 20190127597 | ISBN 9781772272697 (softcover)
Subjects: LCSH: Shorelines—Juvenile literature.
Classification: LCC GB453 .H34 2019 | DDC j551.45/8—dc23

A Walk on the Shoreline

by Rebecca Hainnu · Illustrated by Qin Leng

INHABIT
MEDIA

NUKAPPIA LAY AWAKE in bed with the bright sunlight shining through the curtains. He found that each summer he visited the Arctic, it took some time before he was used to the twenty-four hours of sunlight. Nukappia lived with his adoptive parents in Ottawa but spent summers with his biological family in the small community of Clyde River, Nunavut.

Nukappia loved coming to the North for long visits. His family never seemed to stay in the little town for long. They were always fishing, hunting, or harvesting berries. He loved both families very much, and sometimes he wished they could all just live together.

But this night, it wasn't just the sun that was keeping him awake. He was spending one night in town with his uncle Angu, and then they were going to walk to his grandparents' annual camp, where he would spend weeks camping with his entire northern family on the shoreline.

WHEN MORNING FINALLY CAME, Nukappia packed a small backpack full of snacks, tea, and a Thermos full of soup to bring along on their walk to the campsite. Uncle Angu always walked to the camp, rather than taking a short ATV ride. It would be much faster to go by ATV, but Uncle Angu insisted there was much more to see on foot than could be seen when riding on a loud machine.

The two made their way to the shore, leaving the small town. As they walked farther away from town, the sounds of trucks and ATVs began to fade. The sky was bright with shades of blue and a few patches of cloud. As they moved closer to the shore, Nukappia could smell the sea. He took a moment to take it all in.

ALL ALONG THE SHORELINE, Nukappia saw dried seaweed spread across the beach.

"Is that seaweed the edible kind?" Nukappia asked his uncle. He remembered eating a delicious seaweed soup one summer when he visited.

"Yes," replied Uncle Angu. "It can be eaten raw or dipped in hot broth or boiling water. Seaweed is not only delicious, it's also used as medicine. It has lots of nutrients and minerals, so it is good for people who need more iron in their diets."

AS THEY WALKED ON, Nukappia and Uncle Angu followed the shore until they reached a river flowing out into the ocean. Where the river met the ocean, the ocean water was clear of ice and moving swiftly, while farther away from the river, winter ice still covered most of the water. They followed the river a short distance until the river narrowed. The narrow parts of the river were shallower, making it easier to cross.

At the river, a few people were fishing near a weir with kakivaks, traditional fishing spears. They were cheerfully catching char, using quick motions as they pulled out huge fish that seemed to almost break their thin kakivak handles. Nukappia smiled as he looked on.

NUKAPPIA AND UNCLE ANGU continued to walk past the river and eventually stopped by some rocks overlooking the sea to eat some soup and drink tea. Although it was summer, it was a lot colder than the summer weather in the south, so the soup provided Nukappia with some much-needed warmth. Nukappia told his uncle all about the new school he was going to, how he had made new friends, and that he had learned to play the piano. After they finished their meal, Nukappia noticed two boys in the distance, out on the sea ice.

"Isn't that Mukpa and Sakiasie?" Nukappia asked, excited to see two of his cousins, whom he hadn't seen since last summer. "What are they doing?"

"Yes, that's them. They are digging for clams and jigging for sculpin," Uncle Angu explained. "Let's go see what they've caught!"

NUKAPPIA AND UNCLE ANGU made their way onto the sea ice, stepping on very slippery rocks covered in rock algae. Nukappia remembered his grandmother boiling dried algae to make dye for the traditional dolls she was always sewing.

The terrain changed from earth and rocks to snow. With each step they took, the snow crunched under their feet. As they approached the boys on the ice, Nukappia noticed several creatures lying at the boys' feet. He did not recognize some of the creatures they had caught.

After greeting each other with tight hugs, Nukappia asked his cousins what they were doing.

"I AM DIGGING FOR CLAMS," Mukpa said, holding up a clear bag of water that was filled with live clams. "I use this suction pole to get clams from the ocean floor," Mukpa said, showing Nukappia how to slide the tool into a crack in the sea ice. "Then I scoop them up with this net."

The suction pole looked to Nukappia like a small plunger attached to the end of a very long pole, while the net resembled a soup ladle, but with a very long handle.

"I didn't know you could catch clams through a crack in the sea ice!" Nukappia said with surprise.

"You can," Uncle Angu responded. "As long as you have long enough tools for the area you are digging in. There are other ways to collect clams, too. In places where there are low tides that reveal more of the ocean floor, people on foot can use a small shovel to dig clams. In some places in the North, people even collect clams by scuba diving."

Nukappia could imagine how cold it must be to scuba dive in the North. The thought made him shiver.

"These clams will be a great addition to the family feast tonight!" Mukpa said.

AS NUKAPPIA WAS ADMIRING Mukpa's bag of clams, a big splash came from behind him.

"I've got another sculpin!" Sakiasie yelled as he pulled an odd-looking fish out of the water and onto the ice.

"Wow," said Nukappia, "I've never seen one of those before!"

"Sculpin is a tough, bottom-feeding fish," Uncle Angu chimed in. "It never freezes, even in the coldest Arctic waters. Sculpins stay in the ocean all year long, unlike the char that swim to inland tundra lakes in the wintertime. They have a special kind of anti-freezing power! Grandma wanted to make some fresh sculpin stew for the feast. This is a big one, and it probably has some eggs inside it as well. Grandma will like it!" Uncle Angu said with a grin.

"In the old days, whenever someone had no appetite, or had an upset stomach, that person was encouraged to eat boiled sculpin," Uncle Angu continued. "After eating the sculpin, that person would regain their appetite."

"Sculpin is the best-tasting medicine for the sick, but you do not have to be sick to eat it!" Sakiasie exclaimed.

SAKIASIE ADDED THE BIG SCULPIN to the rest of his day's catch: three other sculpins and two green sea urchins. Nukappia had read about urchins at school. He knew the urchins found in the Arctic are usually red or green, and that their bodies are covered in spines, which help protect them from predators.

"I read about those at school," Nukappia said, pointing to the urchins. "But I've never seen one up close. How does it eat with all those spikes?"

"The urchin's skeleton is like a shell, it is on the outside of its body and is made up of these hard spines," Uncle Angu said as he carefully picked up the urchin and showed it to the boys.

"The mouth of the urchin is on the bottom of its body, and it feeds on debris that it finds on the ocean floor. Urchins have tiny tube feet that have special sensory organs on them. They move around with their feet, but they can also use their spines to lift their entire bodies up off the ocean floor."

"In school they told us that some urchins are poisonous," Nukappia replied with concern.

"Not this one," Sakiasie piped up. "We're bringing it to Grandma to prepare for the feast!"

BEFORE LONG, it was time for the boys to pack up and continue their walk to the family's camp for the night's feast. Nukappia's cousins picked up their clam-digging tools and jigging sticks, and collected the sculpins, clams, and urchins they had caught.

As the boys tramped over the sea ice and onto the shore, Nukappia listened to stories about all that had happened during the year. The walk to camp was noisy and cheerful; they had so much to talk about!

Nukappia breathed in the fresh, salty ocean air. Although it was late in the evening, the bright Arctic sunlight shone on the icy shore.

AS THEY WALKED, Uncle Angu pointed out a few more animals and plants along the way: a starfish, sitting still in the shallow waters of the shore, long grasses called foxtail growing a short distance from the waterline, and several different types of seaweed that had washed up from the depths of the ocean.

"All of these plants and animals have been used by Inuit for many generations," Uncle Angu told the boys. "Almost everything that can be found on the shoreline is useful as either a medicine, food, or a helpful tool."

Nukappia smiled up at his uncle. He was excited to spend the rest of the summer at the shoreline camp with his family, learning more about the ocean and its many creatures.

TIRED, BUT FILLED WITH EXCITEMENT about seeing his grandparents, uncles, aunts, and more of his cousins, Nukappia rushed ahead as the group neared the camp. Several tents were set up, and the wonderful aroma of burning heather came from the fire. Char was drying on wooden racks.

He could see his grandfather sitting behind the waiting spot—the low wall of rocks that he would wait behind when hunting for seals—drinking a cup of steaming tea. Nukappia's grandmother was just coming out of one of the tents. He could see some of his aunts and uncles preparing more food for the feast by the cooking rocks. Nukappia's mouth began to water at the thought of the delicious meal that was to come. His many cousins were spread around the campsite, playing with rocks near the shore.

Nukappia could hardly believe that he was finally with his entire northern family again.

FILLED WITH HAPPINESS, his heart threatening to jump out of his chest, Nukappia began to run towards his family.

He called out with excitement, "Grandma! Grandpa!"

When his grandparents saw him, they smiled and made their way to meet him, along with the rest of the family.

Nukappia had missed them so very much.

This was going to be a great summer!

Ammuumajut (Um-moo-ma-you)

English: Clams • Scientific: *Bivalve*

- Clams can measure from 0.5 cm to 10 cm in length.
- The colour of clams varies from yellowish grey to brown, white, olive green, or black. Typically, the inside of a clam's shell is white.
- Clams breathe and feed through gills.

Traditional Uses:
- Clams are rinsed and boiled in water. The clams, along with the broth, are delicious.

Aqajait (A-ka-ya-it)

English: Algae • Scientific: *Chlorophyta*

- The colour of aquatic rock algae varies from yellow to orange, green, or black.
- When the algae dries, it can be peeled from the rock in flakes.

Traditional Uses:
- Inuit boil dried algae in water. Once the colour of the water becomes the colour of the algae, it can be used as a dye for cloth.

Iqaluk (E-ka-look)
English: Char • Scientific: *Salvelinus alpinus*

• Arctic char can weigh 9 kg or more.
• These fish vary in colour, depending on the time of year and the environmental conditions of the lake where the fish lives. Usually the fish is silver with a pinkish line across its body.

Traditional Uses:
• Arctic char are caught using kakivaks, fishing rods, jigging sticks, and nets.
• Arctic char can be eaten raw, cooked, or dried.
• The skin of the Arctic char was traditionally used to make sewing bags. The bones were used as toys.

Ittiq (E-tick)-Miqqulik (Me-koo-lick)
English: Urchin • Scientific: *Strongylocentrotus droebachiensis*

• Urchins can measure from 6 cm to 12 cm in diameter.
• In the Arctic they are usually green, but a species of red sea urchin also lives there.
• They have spines covering their entire bodies, which protect them from predators. These spines form a type of skeleton on the outside of the urchin's body.
• The urchin's mouth is on the bottom of its body. Urchins feed on organic debris found on the ocean floor.
• Urchins have tube feet that have sensory organs on them. They move around with their feet but can also use their spines to lift themselves off the ocean floor.

Traditional Uses:
• Urchins are edible. They are considered a delicacy.

Ivik (E-vik)

English: Foxtail • Scientific: *Aloperurus borealis*

- Ivik grasses grow from 10 cm to 15 cm in length.
- The plant is dark green, and the tip of it looks like a fox's tail.

Traditional Uses:
- Inuit traditionally used grass to weave baskets. They also used grass as insulation between rocks and earth when building sod houses.
- Lemmings gather grass in the fall and make a grass ball. The ball serves as a food source during the winter months. Lemmings give birth to their babies inside the ball of grass, where the babies can feed and stay warm.
- In some places, the tips of blades of grass were traditionally chewed like a gum.

Kanajuq (Can-a-yook)

English: Sculpin • Scientific: *Cottidae*

- Sculpins can measure from 5 cm to 55 cm in length.
- The colour of this fish is usually brownish grey with orange or pink spots.
- Sculpins live in shallow waters near the shore.

Traditional Uses:
- Sculpins were traditionally fished at cracks in the ice near the shore.
- Sculpins are the easiest fish to catch. They are bottom-feeders, so you just have to make sure your bait or hook reaches the very bottom and then "jig," making small movements with your wrist. Even small pebbles can be used to catch sculpins.
- Boiled sculpin was eaten to treat chronic vomiting. Elders and other people who had no appetite were encouraged to eat boiled sculpin. After eating sculpin, a person would regain their appetite.

Kuanni (Koa-knee)

English: Seaweed • Scientific: *Alaria esculenta*

- Seaweed varies widely in size.
- Some seaweed types are flatter than others.
- There are a variety of lovely greens in the seaweed found in the Arctic.

Traditional Uses:
- Seaweed can be cleaned in fresh water, or wiped clean and eaten raw.
- Before eating seaweed, the leafy parts should be removed. To remove the leafy parts, rip the base of the leaf and, holding the stem firmly, pull the seaweed between your thumb and forefinger.
- Seaweed is a good source of nutrients and minerals. People who are anemic (who lack iron in their blood) benefit from eating seaweed.
- People are warned not to eat too much seaweed. Like anything else, too much of it is not good for you.

As you walk along the shoreline, various landforms and structures indicate how different parts of the shoreline can be used.

Fishing Weirs

Traditionally, fishing weirs were the main way that Inuit caught fish, before fishing nets, rods, and lures were available.

In the early part of summer, before the char moved out of tundra lakes and into the ocean, people constructed weirs out of rocks in the rivers that lead to the ocean. A weir consists of two rock walls built across the river. The wall that the fish come to first as they travel down the river has a break in it, which the fish can pass through. The second wall is solid, so that the fish cannot move past it.

Fishermen would wait for the char to run into the weir and then use a kakivak, a traditional fishing tool, to harvest the fish. Once the fish had been harvested, the walls of the weir were removed, so that the fish could cross freely through the river.

Inuksuit

Inuksuit are stacks of rocks, ranging in size from large boulders to small stones. Along the shoreline, inuksuit mark good spots to fish for char and sculpin.

Utaqqiurviks

Utaqqiurviks, commonly known as waiting spots, are small walls of rocks used to hide hunters while they wait for sea mammals, such as seals and whales. If you see a waiting spot along the shore, that means that a hunter has used that spot.

Contributors

Rebecca Hainnu

Rebecca Hainnu lives in Clyde River, Nunavut, with her daughters Katelyn and Nikita. Her work includes *Math Activities for Nunavut Classrooms* and *Classifying Vertebrates*. She is also the author of *The Spirit of the Sea*, and co-author, with Anna Ziegler and Aalasi Joamie, of *Walking with Aalasi: An Introduction to Edible and Medicinal Arctic Plants*. Her book *A Walk on the Tundra*, also co-authoured with Anna Ziegler, was a finalist for the 2013 Canadian Children's Literature Round Table Information Book Award, and was among the 2012 "Best Books for Kids and Teens," as selected by the Canadian Children's Book Centre.

Qin Leng

Qin Leng was born in Shanghai, China, and lived in France and Montreal. She now lives and works as a designer and illustrator in Toronto. Her father, an artist himself, was a great influence on her. She grew up surrounded by paintings, and it became second nature for her to express herself through art. She graduated from the Mel Hoppenheim School of Cinema and has received many awards for her animated short films and artwork. Qin has always loved to illustrate the innocence of children and has developed a passion for children's books. She has illustrated numerous picture books for publishers in Canada, the United States, and South Korea.

Toronto • Iqaluit
www.inhabitmedia.com